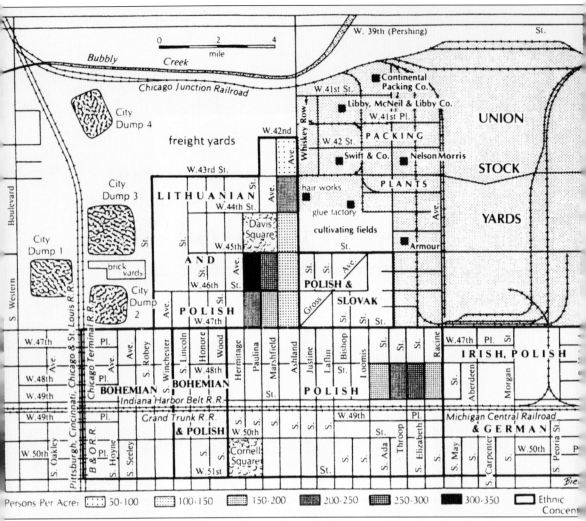

Persons Per Acre: 50-100    100-150    150-200    200-250    250-300    300-350    Ethnic Concentr

The Back of the Yards neighborhood was surrounded by the stockyards, railroad tracks, and city dumps. Some blocks in the neighborhood were more crowded than others, as seen in this map from the article "Housing Conditions in Chicago, Ill: Back of the Yards" in the January 1911 edition of the *American Journal of Sociology*. The map also shows ethnic enclaves.

*On the cover:* Please see page 9. (Courtesy of the Back of the Yards Neighborhood Council.)

IMAGES
*of America*

# BACK OF THE YARDS

Jeannette Swist

ARCADIA
PUBLISHING

Published by Arcadia Publishing
Charleston SC, Chicago IL, Portsmouth NH, San Francisco CA

Printed in the United States of America

Library of Congress Catalog Card Number: 2007923519

For all general information contact Arcadia Publishing at:
Telephone 843-853-2070
Fax 843-853-0044
E-mail sales@arcadiapublishing.com
For customer service and orders:
Toll-Free 1-888-313-2665

Visit us on the Internet at www.arcadiapublishing.com

This book is dedicated to Jim, Jonathan, and Lauren Lukacek; to the memory of my parents, John and Emily Swist, and grandparents; and to the immigrants and working people of Back of the Yards.

# CONTENTS

# ACKNOWLEDGMENTS

Thank you Joseph B. Meegan and Saul Alinsky for your work! I wish to thank the Back of the Yards Neighborhood Council, especially Patrick Salmon, James Gonska, and Sean O'Farrell and the *Back of the Yards Journal* staff who provided access to their archives and workspace.

There are several people who opened their private collections and shared their time and history with me. I wish to thank Marlene Traksel Feldhaus, Loretta Ezerski, Gerri Walski Lozuk, Marilyn Kareiva Zelasko, Lottie Stegvilas Tervanis, Carol Kolling Rickards, James Kopulos, Connie Scribano Kopulos, Jackie Kopulos Chico, Connie Jvarksy, Clarence J. Stoskus Jr., Tom Doyle, Rose Gaura Doyle, Roxanne Rumsa, Caryn Olczyk, Fred Symons, Alice Lach Oskvarek, and the Raukstas family in Panevezys, Lithuania.

I am grateful to Fr. Bruce Wellems of Holy Cross-Immaculate Heart of Mary Church for sharing some archival photographs. Thank you to Sr. Joellen Tumas and Sr. Margaret Petcavage for help in identification. Thanks to David and Cary Schultz, and Liam and Joe McDonnell for sharing their grammar school graduation class photographs.

I especially wish to thank Marlene Traksel Feldhaus and Ed Feldhaus for their hospitality and setting up get-togethers at their home to meet with others. I am forever grateful to them.

I sincerely appreciate the sisters of St. Casimir for introducing me to the concept of "the calling" back in grammar school, and Darlene Mack for sending me the gift of Debbie Call's book *Tug of Heart* that accelerated the chain of synchronistic events that led me back to the yards.

*Aciu!* to Giedrius Subacius, who readily offered his assistance. It was encouraging to see the outcome of his book that followed the trail of Upton Sinclair and to discuss the neighborhood history.

Many thanks to my husband, Jim Lukacek, for helping me organize the photographs and captions. His patience is greatly appreciated.

My largest debt is to four friends who worked with me on the planning committee for a successful Holy Cross Church centennial in 2004: Clarence Stoskus, George Tafelski, Ben Rosales, Charlotte Davis Saverino Vaitkus. We referred to ourselves as "the Lucky Five." It was discussions with them about a commemorative book for the centennial and Rosales's thought-provoking idea that we needed to be inclusive to the neighborhood that led me in the direction of writing a proposal for this book. Clarence provided the continual nudge to get to work on the book.

Thank you to my talented editor, Melissa Basilone, and to publisher John Pearson for answering my technical questions when I was out in the field.

# INTRODUCTION

The Back of the Yards community has historical significance. The stockyards were the birthplace of American community organization. Upton Sinclair's book *The Jungle* is said to have influenced Pres. Theodore Roosevelt to pass the Pure Food and Drug Act and the Meat Inspection Act in 1906. Mary McDowell founded the University of Chicago Settlement House and worked to close down disease-infested garbage dumps. In the 1930s, Saul D. Alinsky and Joseph B. Meegan created the Back of the Yards Neighborhood Council, which was a coalition of neighborhood and church groups that addressed community issues, workers' rights, and housing conditions. It was the first community organization of its kind in the nation.

The Back of the Yards area was populated by successive generations of immigrant working-class people that had the attention of novelists, activists, and social scientists for most of the 20th century. The area was adjacent to or "in back of" the former Union Stock Yard and its packing plants, which was home to the largest livestock and meatpacking center in the country. In essence, the stockyards were the first assembly line using the mass-production process. The workers were early examples of networking and social change agents. The study of the work performed and the conflicts that erupted between management and the workforce are important subjects in the study of management, sociology, human resources, psychology, and organizational development.

The sprawling yard and its plants took a toll on people in the community with job-related diseases and accidents, packinghouse strikes, low wages, heavy work schedules, a polluted waterway called Bubbly Creek, and the noxious stench, smoke, and pollutants emitted by the fertilizer and meatpacking plants. Tuberculosis and pneumonia were common, and residents considered them fatal. One only needs to ask, where did the people draw their strength to persevere?

A sense of community was solace for the workers. While stockyard lunchrooms, churches, parochial schools, stores, funeral homes, and cemeteries may have provided a sense of order and a feeling of home for ethnic enclaves, a melting pot was brewing. A walk down the block might find a home with Polish or Slovak families while a turn of the corner would find a concentration of Lithuanians or Bohemians. In later years, Hispanics also mixed into the neighborhood. One would hear many different languages and smells of food, and every ethnicity learned to understand each other's languages and customs. Catholicism was the foundation that served to bridge the gap between ethnic divisions, but other establishments, such as taverns and neighborhood stores, were also important for providing a strong sense of community. They were scattered throughout the residential blocks, and many of the taverns served meals.

In 1971, Chicago's Union Stock Yard officially closed. Today the area is home to an industrial park. A limestone arch and steer head, erected between 1875 and 1879, marked the entrance to

the stockyards on the east side. The stand-alone arch is all that remains of the historic industry that began in 1865. In 2005, the Friends of Libraries USA (FOLUSA) announced that the Union Stock Yard gate would be added to the organization's roster of literary landmarks. This commemorated the centennial of Upton Sinclair's novel *The Jungle*.

Many changes have been made in the area. In a residential area that was once in walking distance to shopping, theaters, schools, churches, and restaurants, parking lots abut the same streets where Chicago Transit Authority buses run today. Over the city dumps that Mary McDowell fought to close, a Damen Avenue overpass was built. Next to the overpass and over those filled dumps, the area was transformed every summer for decades during the month of July to host the Chicago Free Fair. Today a new shopping mall operates at the corner of Forty-seventh Street and Damen Avenue, and the overpass was demolished.

Much architectural history and potential Chicago landmarks have been razed in the Back of the Yards neighborhood. The teardown trend has radically altered the character of the neighborhood. While new buildings are erected, they lack the interesting designs that gave the neighborhood a sense of style such as porch trimmings and turrets. The Back of the Yards community has lost the McDowell Settlement, Guardian Angel Nursery, Drovers Bank, and Peoples Theater, as well as numerous homes, taverns, neighborhood stores, churches, and schools.

The Back of the Yards is where I lived and grew up. It is where the maternal side of my family lived, including my mother and uncle, and grandmother and grandfather, who emigrated from Lithuania. They would not have met in Lithuania due to distance, as he was from Kaunas and she was from the Panevezys area. In 2004, I completed some genealogical research based on some letters from the 1930s from my grandmother's family who lived outside Panevezys. I was able to locate Vygandus Raukstas, a relation who spoke English. Raukstas's father and aunts were my grandmother's nieces and nephew. I decided to plan a trip to Lithuania to visit them.

Upon my return to the states from Lithuania, I received a call from a friend from grammar school to remind me that it was the centennial year for Holy Cross Church, and she wondered what the date for the celebration would be. Needless to say, I found myself involved in the planning committee for the parish's centennial along with former grammar school friends who wanted to get together for a reunion, including Clarence Stoskus, George Tafelski, Ben Rosales, and Charlotte Davis.

The idea for this book was initially conceived during the centennial of the parish. It was Rosales's inspiring statement that the book should be "inclusive not exclusive" of the Back of the Yards community that was the spark that lead me to write this book. It is the hope that *Back of the Yards* provides a way to see the interesting buildings, feel the excitement of the parades, experience the fun of the month-long free fair, and visit the homes and see into the lives of the neighborhood residents. The responsibility for any errors lies with me.

# One

# PEOPLE, FAMILIES, EVENTS, AND ESTABLISHMENTS

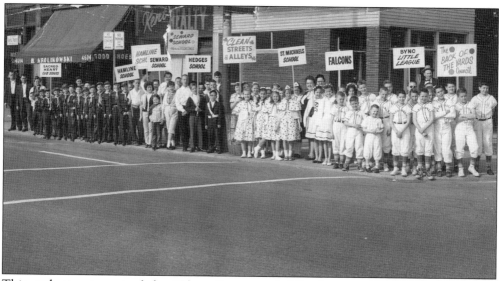

This gathering is part of the "Clean Streets and Alleys" campaign that began in 1956 and 1957 after Mayor Richard J. Daley's "Pitch in for Chicago" campaign. The group is at 4600 South Ashland Avenue, outside the office of the Back of the Yards Neighborhood Council and the Kent Realty office, and adjacent to the 4604 South Ashland Avenue storefront of B. Krolikowski Good Shoes. The photograph features Sacred Heart Cub Scouts, Hamline School, Seward School, Hedges School, St. Michael's School 4H Club, Falcons, and the Back of the Yards Neighborhood Council Cardinals Little League.

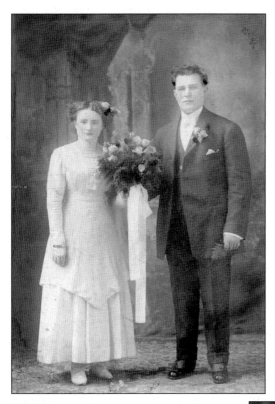

Pictured here are Ursule Raukstaite and Edvardas Druktenis at the 1905 wedding of Edvardas Druktenis and Ona Kasputaite. Edvardas came from the Taurage, Kvedarna parish in Pajure Village, Lithuania. Edvardas and Ona had two daughters, Helen and Matilda, and two sons, Edvardas and Bronislavas. Edvardas worked as as laborer for Armour and Company. He died of tuberculosis on April 20, 1929, at the age of 45 and was buried at St. Casimir Cemetery. (Photograph by Urbanowicz, Chicago; courtesy of Jeannette Swist.)

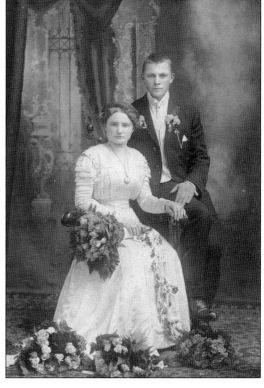

In the 1910 census, Ursule Raukstaite resided with Bagdonas family relatives at 4514 South Paulina Street. Ursule and Pranas Raukstas are seen here about 1910. Pranas was drafted into the army during World War I and died in Germany. Ursule and Pranas came from Panevezys, Vilkamieziu parish in Bigailiu Village, Lithuania. (Photograph by Urbanowicz, Chicago; courtesy of Jeannette Swist.)

On February 27, 1911, Feliksas Druktenis, age 25, married Ursule Raukstaite, age 22, at Holy Cross Church. Their son Vytautas was born in December 1911, and their daughter Amelia (Emily) was born in April 1913. Both were baptized at Holy Cross Church. (Courtesy of Jeannette Swist.)

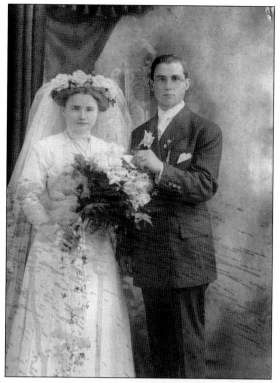

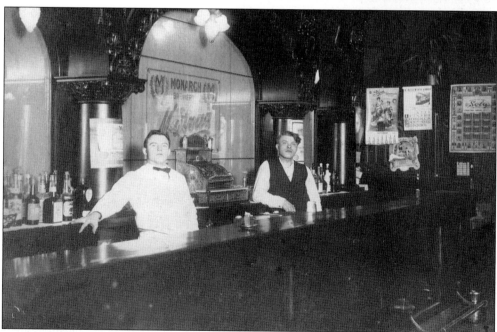

This image of the J. J. Tavern at 4600 South Paulina Street was taken in October 1913. The owner was Joseph Ezerski, seen in the white shirt at age 23. Note the Monarch Beer sign, the brass spittoons on the floor, and the brass rail along the bar with the three-tiered mirror background. (Courtesy of Loretta Ezerski.)

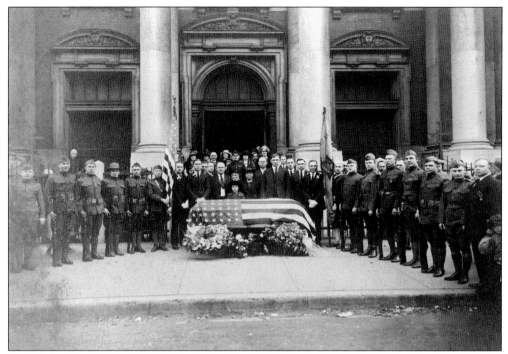

This is the funeral of an unidentified World War I veteran at Holy Cross Church between 1914 and 1918. Joseph Ezerski is in attendance. (Courtesy of Loretta Ezerski.)

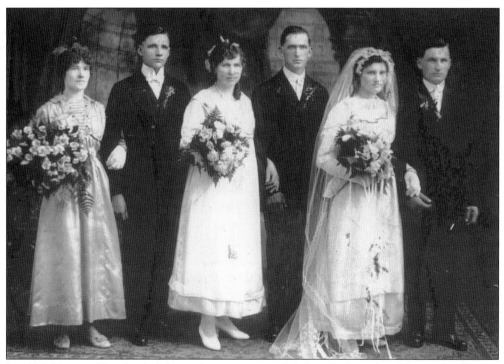

In 1915, Karusia (Caroline) Arbacauskas was married to Joseph Stegvilas. (Courtesy of Lottie Stegvilas Tervanis.)

This is the Druktenis family around 1918. Pictured, from left to right, are Ursule Raukstaite Drukteniene, Feliksas Druktenis (standing), Vytautas Druktenis, Amelia Druktenite (with bow), and stepdaughter Martha. In the 1920 census, the Druktenis family lived at 4312 South Wood Street. (Courtesy of Raukstas family of Panevezys, Lithuania.)

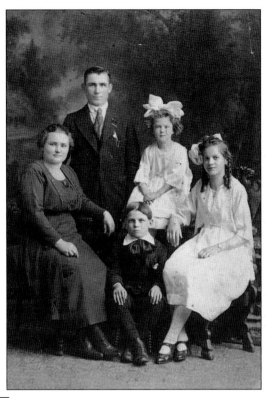

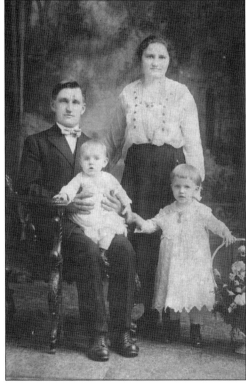

The Stegvilas family is pictured here around 1920. They are Joseph, Caroline, daughter Nancy (Antoinette, born in 1917), and son Johnny (born in 1919). (Courtesy of Lottie Stegvilas Tervanis.)

This is a view from the roof of 1714 West Forty-sixth Street during the 1920s. Emily Wask Kasper is in the photograph. Note the smoke billowing out of the stockyards in the background. (Courtesy of Marlene Traksel Feldhaus.)

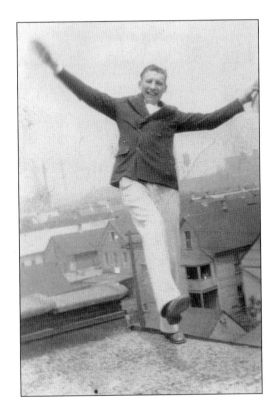

Stanley Wask is on the roof of 1714 West Forty-sixth Street during the 1920s. The buildings in the background are tenements, housing common to the neighborhood. (Courtesy of Marlene Traksel Feldhaus.)

14

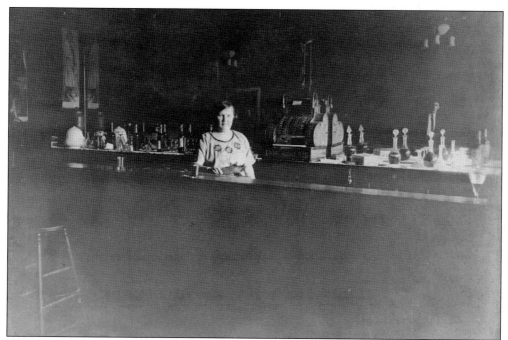

With her kids on the roof, Francis Wask Kasper tends the bar downstairs at Kasper's Tavern in the 1920s. Stanley Wask is the man in the mirror near the cut-glass dispensers on the bar. (Courtesy of Marlene Traksel Feldhaus.)

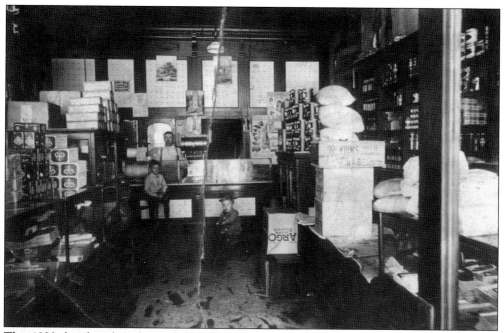

This 1920s butcher shop, located at 4551 South Hermitage Avenue, was owned by George and Barbara Brazauskas. George is seen here with his two young sons, Victor and Edward. He was one of the original organizers of Holy Cross Church. George and Barbara had nine children. (Courtesy of Marilyn Kareiva Zelasko.)

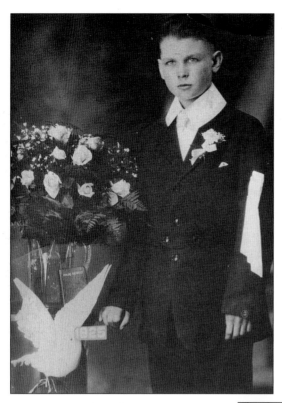

In 1925, Vytautas Druktenis and sister Amelia (Emily) Druktenite received Holy Communion at Holy Cross Church. From 1936 on, Emily worked for Swift and Company in the stockyards. (Courtesy of Jeannette Swist.)

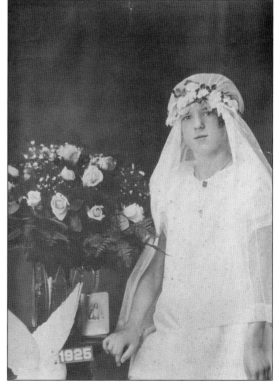

Antonius Druktenis was born in 1868 in Kaunas, Lithuania, and died in 1925 at age 56 from pneumonia. He worked as a watchman. Antonius was grandfather to Vytautas and Amelia and father to Feliksas, Vincentas, and Edvardas Druktenis. (Photograph by Cynal Studios, Chicago; courtesy of Jeannette Swist.)

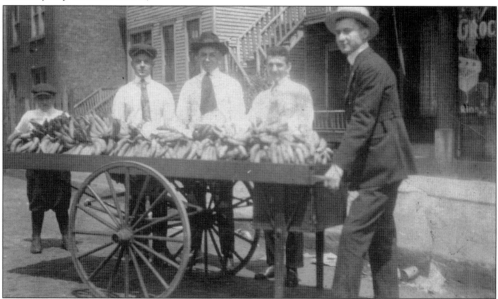

This early-1900s scene is of men selling bananas from a pushcart in front of homes at 4523–4533 South Laflin Street. The Heenan family lived at 4531 South Laflin Street. The grocery store at 4533 South Laflin Street was owned by half brothers Joe Bielak and Frank Lach. In 1925, it became Lach's Grocery and Meat Market, a family business, operated by Frank and Genevieve Lach until its closing on June 1, 1952. An advertisement appears in the window for Rinso detergent. (Courtesy of Alice Lach Oskvarek.)

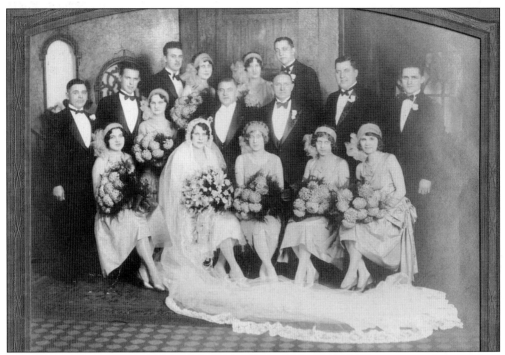

Joseph Ezerski married Antoinette Simonis between 1926 and 1928. They are seen here on their wedding day. (Courtesy of Loretta Ezerski.)

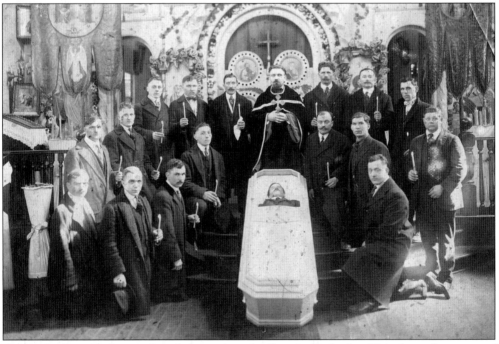

This is the funeral of an unidentified person at the Russian Orthodox Church on the corner of West Forty-fourth Street and Paulina Street in the 1930s. Peter Lozuk is in attendance. He lived at 1718 West Forty-fourth Street. (Courtesy of Gerri Walski Lozuk.)

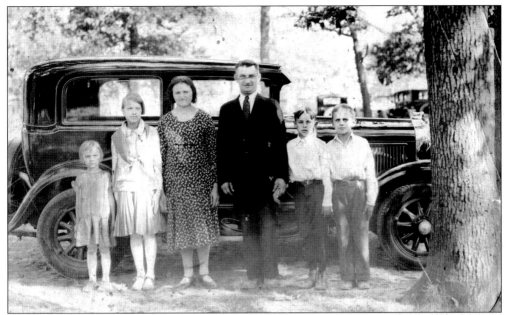

The Stegvilas family is seen here in the 1930s at Vytautas Grove. They are, from left to right, Lottie, Nancy, mother Caroline, father Joseph, Johnny, and Joey. (Courtesy of Lottie Stegvilas Tervanis.)

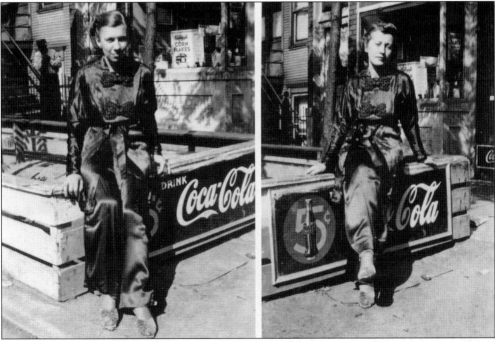

Anna Jucius and Estelle Shimkus are in front of 4523 South Honore Street in the early 1930s. The store was owned by Ursule Raukstaite Drukteniene (Druktenis). Shimkus lived at 4529 South Honore Street, and Anna (left, with man in background) lived next door at 4521 South Honore Street. Note the Kellogg's Corn Flakes box in the window and the sign offering Coca-Cola for 5¢. (Courtesy of Jeanette Swist.)

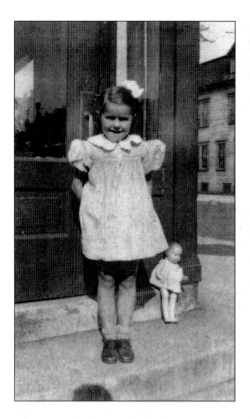

In 1934, Joann Ezerski and her doll stand outside her home at 4600 South Paulina Street. She was the daughter of Antoinette and Joseph Ezerski. (Courtesy of Loretta Ezerski.)

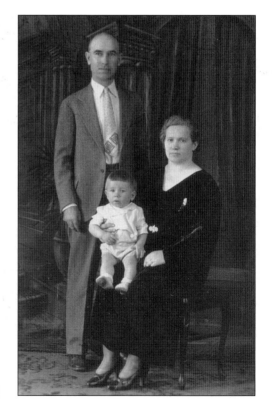

Stanley Walski, Helen Jurshenas Walski, and Stanley Jr. had this photograph taken in 1935. According to Stanley and Helen's daughter, Gerri, 4536 South Paulina Street used to be a furniture store with three apartments. Her parents bought it, and her father made hand-rolled White Rose cigars there. Gerri helped put the cigars in the cellophane and was paid 25¢ for her work. With the money, she bought war bonds in the 1940s. (Courtesy of Gerri Walski Lozuk.)

Antoinette Ezerski and her son Joseph (Joey) are seen here in 1936 along with their dog Taxi. The lamppost is reflected in the window of the door at 4600 South Paulina Street. (Courtesy of Loretta Ezerski.)

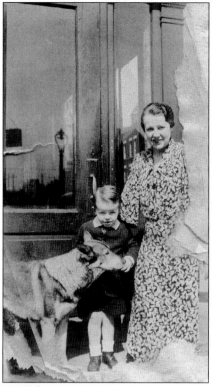

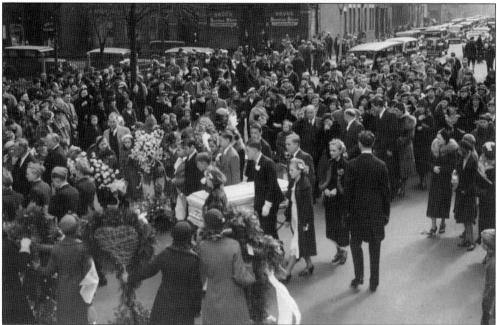

This funeral at Holy Cross Church on the corner of West Forty-sixth Street and Hermitage Avenue was for Johanna (Joann) Ezerski, age 6, in 1936. She passed away from double pneumonia. Grieving parents, Antoinette and Joseph, and family members Ben, George, Hazel, and Mike Ezerski follow behind the casket. Many turned out for the funeral. (Courtesy of Loretta Ezerski.)

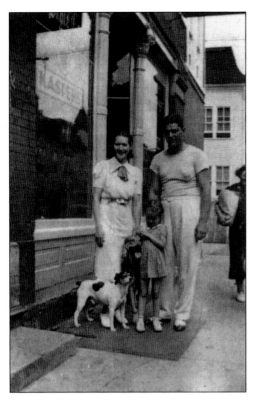

The Traskel family stands in front of 1714 West Forty-sixth Street at Kaspers Old Style Lager in 1937. They are, from left to right, Emily Wask Traksel (mother), Marlene Traksel (daughter), and Connie Traksel (father). Francis Kasper is walking by. The dogs were named 50-50 and German. The building in the background, on the corner of 4558 South Paulina Street, is Kuszlejko's saloon and is the most probable location of the wedding celebration that Upton Sinclair observed and described in his book *The Jungle*. For his book *Upton Sinclair: The Lithuanian Jungle*, the author Giedrius Subacius researched this location.(Photograph by Marlene Traksel Feldhaus.)

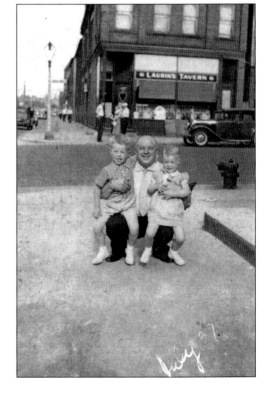

Laurin's Tavern was located directly across the street from the Ezerski's J. J. Tavern. Joseph Ezerski and his two children, Joseph Jr. and Loretta, are in this photograph on the corner of Forty-sixth Street and South Paulina Street in 1937. (Courtesy of Loretta Ezerski.)

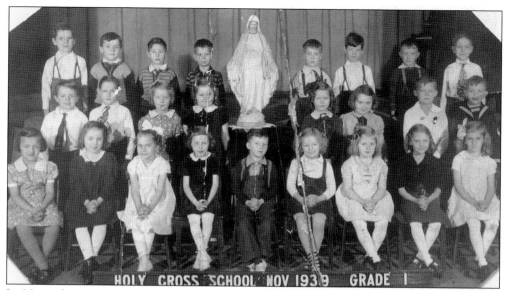

In November 1939, the Holy Cross Grammar School mixed-use class, grades kindergarten and 1, pose for a portrait. They are, from left to right, (first row) Irene Legner, Joann Lukas, Arlene Stulginskas, Marilyn Kareiva, Anthony Acas, Hortense "Ticki" Nemunas, Bernardine Kauffmann, Dorothy Miller, and Harriet Kauffmann; (second row) Joe Ezerski, Raymond Rimkus, unidentified, Alvira Masla, Alice Martinkus, Marlene Traksel, Aldona Kuzavynas, and unidentified; (third row) unidentified, unidentified, Edward Turas, Ronald Cervic, Richard Dockus, and three unidentified children. (Courtesy of Marlene Traksel Feldhaus.)

In the early 1930s, the Kolelis family had this photograph taken on 1718 West Forty-fourth Street. Pictured, from left to right, are sons William "Duke" and Adam, wife Ona Kolaliene Kolelis, daughter Frances, and husband Boleslovas (William) Kolelis. (Courtesy of Carol Kolling Rickards.)

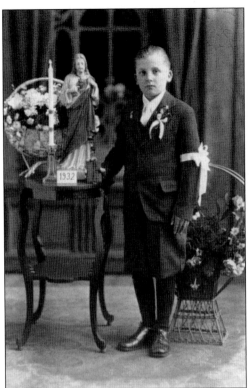

This is the 1932 Holy Communion of Adam Kolelis. (Courtesy of Carol Kolling Rickards.)

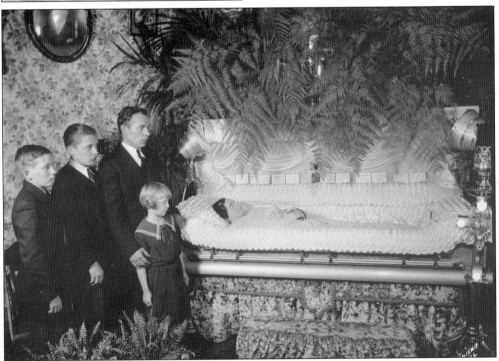

The funeral for wife and mother Ona Kolaliene Kolelis was held in 1936 at the home at 1718 West Forty-fourth Street. (Courtesy of Carol Kolling Rickards.)

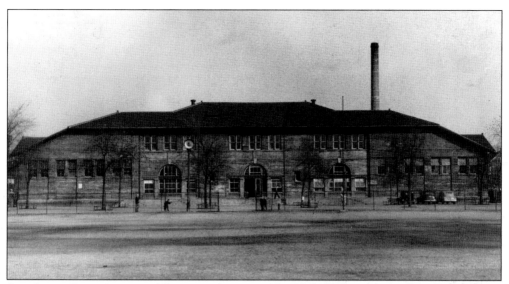

Seen here is Davis Square Fieldhouse in the 1930s. The Back of the Yards neighborhood featured three innovative parks providing social services and open space to the blocks of congested tenements. The parks included playgrounds, ball fields, gymnasiums, public bathing facilities, meeting rooms, outdoor pools, and the earliest branches of the Chicago Public Library. Davis Square Park, established in 1905 and located at 4430 South Marshfield Avenue, pays tribute to Dr. Nathan Smith Davis (1817–1904), a significant figure in Chicago's medical history. (Photograph by Bob Waidler, courtesy of the Back of the Yards Neighborhood Council.)

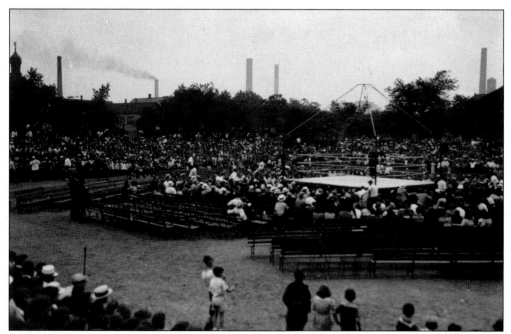

On June 29, 1938, Davis Square Park hosted a citywide boxing tournament. It drew large crowds, as seen here with the stockyards in view and the Russian Orthodox Church on West Forty-fourth Street at Paulina Street at far left. (Photograph by Chicago Park District, courtesy of the Back of the Yards Neighborhood Council.)

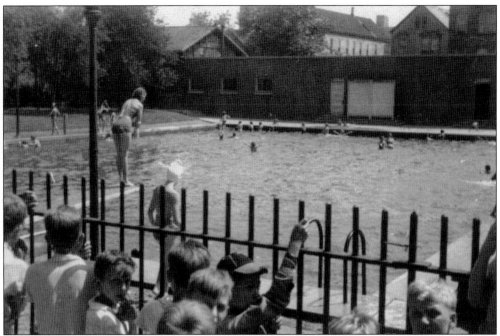

This is the Davis Square pool in the late 1930s or early 1940s with tenements shown along the 4400 block of South Marshfield Avenue. (Courtesy of the Back of the Yards Neighborhood Council.)

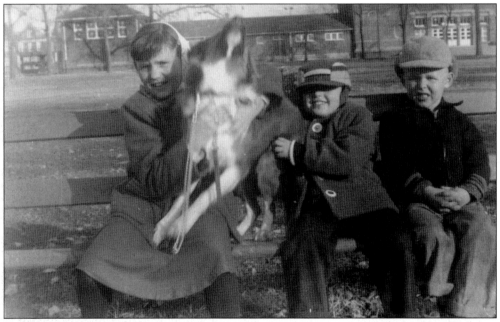

Cornell Square Park, located at 1809 West Fiftieth Street, was named in 1904 in honor of Paul Cornell (1822–1904), a lawyer and real estate developer who was a leading force behind the creation of the South Park System. Seen at the park in 1960, from left to right, are Diane Tervanis, Tommy Tervanis, Joey Kolodziejcak ,and dog Lassie with the Cornell field house in the background. (Courtesy of Lottie Stegvilas Tervanis.)

Sherman Park, established in 1905, was at 1301 West Fifty-second Street. At 60 acres, Sherman was one of the largest of the parks. It featured a waterway, ball fields, a field house, and gymnasium and locker buildings united by pergolas. The park was named for Daniel Burnham's father-in-law, John B. Sherman (1825–1902). Margaret Brehm Pauls is with her mother, Margaret Brehm, in this photograph taken at the park in 1920s, when Pauls resided at 1702 West Fifty-first Street. (Courtesy of James Lukacek.)

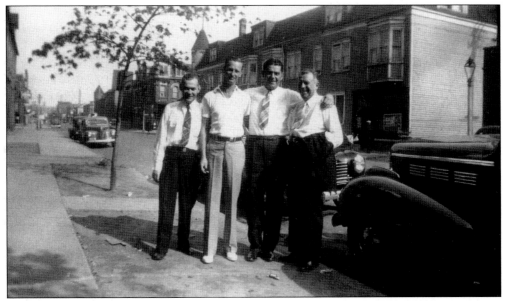

Standing on West Forty-sixth Street between South Paulina Street and Hermitage Avenue in 1947 or 1948, are, from left to right, an unidentified person, Joe Rimkus, Connie Traksel, and William Kasper. Notice the Ezerski building and tavern across the street at the corner of 4600 South Paulina Street. (Courtesy of Marlene Traksel Feldhaus.)

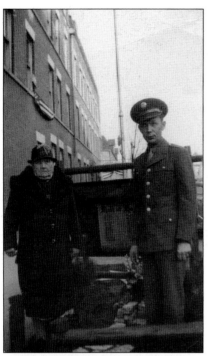

In 1941, Charles Yaki and his mother, Josephine Yakubouski, stand in front of a victory garden with the roll of honor at the corner of 4559 South Hermitage Avenue for servicemen who lived in the neighborhood. (Courtesy of Marlene Traksel Feldhaus.)

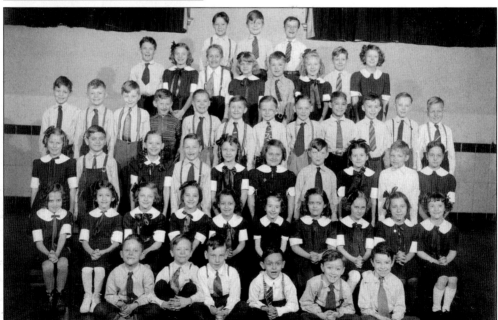

The second graders at St. Rose of Lima Grammar School in 1942 pose for a class portrait. St. Rose of Lima Church, an Irish church at 1456 West Forty-eighth Street, was founded in 1881 and was the first Irish church in Back of the Yards. The church was closed in 1990. A few identified classmates include, third row, far left, Loretta Lorenzen; fifth from left, Florence Haas; and next to her is Rose Gatto. In the same row on the right is Rose Gaura, and third in on the right is Patricia Burns. In the fifth row, third from the right is Geraldine Kwinn. Geraldine is a niece of Dr. Frank C. Kwinn (Kviecinskas), who was a well-known neighborhood physician (Courtesy of Alice Lach Oskvarek.)

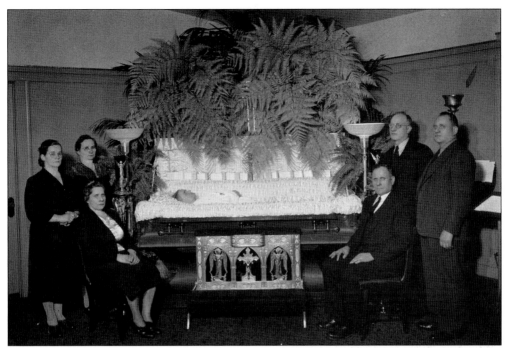

Domicele Jursziene's wake was held at Eudeikis funeral home at 4605 South Hermitage Avenue on November 25, 1942. Her daughters were, from left to right, Helen Walski, Adele Bovshis, and ? Rimsha, and her sons were Victor, John, and Vystasis. (Courtesy of Gerri Walski Lozuk.)

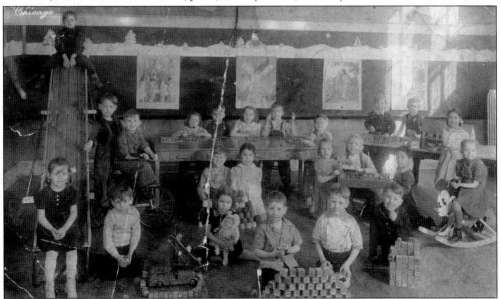

Rev. A. Valancius and Helen Kareiva organized the Holy Cross Ladies Society in 1939 and opened this kindergarten in March 1941. Pictured are Loretta Sprainis on the slide, Stanley Walski with the blocks, Jacqueline Kopulos with the doll, Marlene Cervic on the rocking horse, Betty Kuszlejko next to the boy at the desk, and Sophie Ausura (left) at the desk. In order to raise funds to improve the school and open the kindergarten, bazaars, card and bunko parties, dances, and dinners were held. (Photograph from Jackie Kopulos Chico, courtesy of Marilyn Kareiva Zelasko.)

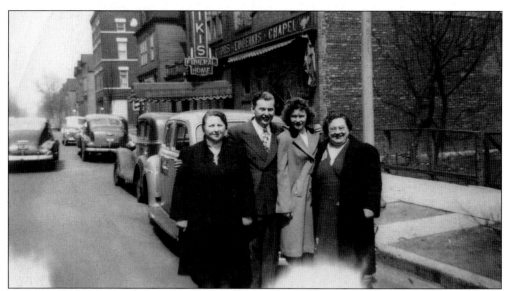

From left to right, Stella Gudanick, Walter Gudanick, Josephine (Jo) Gudanick, and Josephine Stoskus are pictured here in the 1940s on the 4600 block of South Hermitage Avenue with the Eudeikis funeral home sign in background. (Courtesy of Clarence J. Stoskus Jr.)

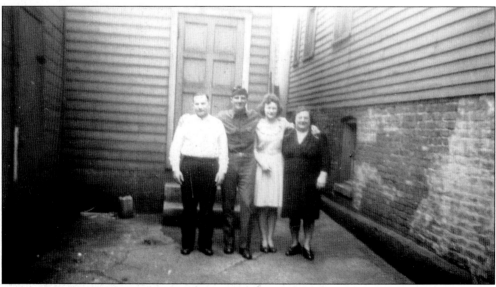

In April 1944, from left to right, Joseph Stoskus, his son Clarence Sr., his sister Josephine, and mother Josephine Stoskus are seen at the rear of their home at 4617 South Hermitage Avenue. (Courtesy of Clarence J. Stoskus Jr.)

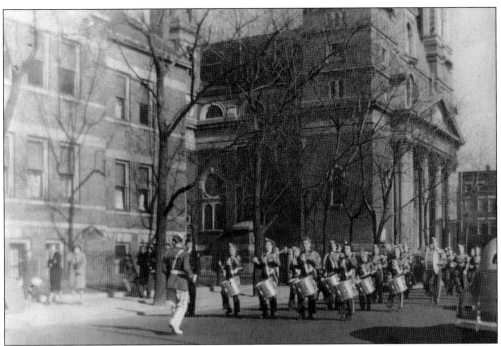

This parade and ceremony acknowledging World War II servicemen listed on the roll of honor was held in the 1940s in front of the Holy Cross Church garden. (Courtesy of Connie Jvarsky.)

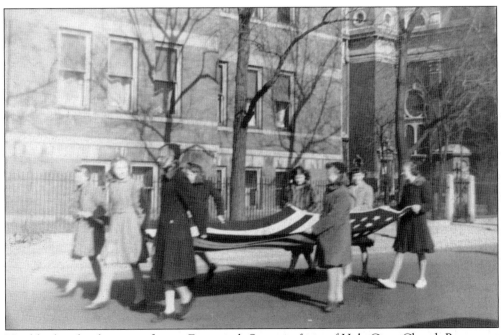

Neighborhood girls carry a flag on Forty-sixth Street in front of Holy Cross Church Rectory at the same parade. (Courtesy of Connie Jvarsky.)

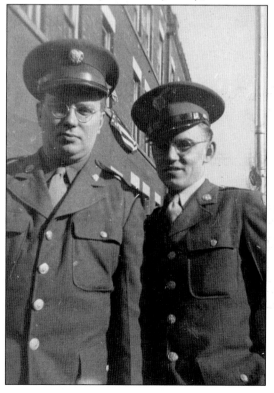

UNITED STATES OF AMERICA
OFFICE OF PRICE ADMINISTRATION

724791 CC

# WAR RATION BOOK No. 3 — Void if altered

NOT VALID WITHOUT STAMP

Identification of person to whom issued: PRINT IN FULL

Jvarsky

(First name)      (Middle name)      (Last name)

Street number or rural route 4526 So Hermitage Ave

City or post office Chicago     State Ill.

| AGE | SEX | WEIGHT | HEIGHT | OCCUPATION |
|-----|-----|--------|--------|------------|
| 32. | F. | 155 Lbs. | Ft. 5 In. 2 | Housewife |

SIGNATURE Stephany Jvarsky
(Person to whom book is issued. If such person is unable to sign because of age or incapacity, another may sign in his behalf.)

**WARNING**
This book is the property of the United States Government. It is unlawful to sell it to any other person, or to use it or permit anyone else to use it, except to obtain rationed goods in accordance with regulations of the Office of Price Administration. Any person who finds a lost War Ration Book must return it to the War Price and Rationing Board which issued it. Persons who violate rationing regulations are subject to $10,000 fine or imprisonment, or both.

OPA Form No. R-130

**LOCAL BOARD ACTION**

Issued by _____
(Local board number)     (Date)

Street address _____

City _____ State _____

(Signature of issuing officer)

This is Stephanie Jvarsky's World War II ration book. Jvarsky lived at 4526 South Hermitage Avenue. (Courtesy of Connie Jvarsky.)

John Matamaitis (left) and John Stegwell are pictured here at 4521 South Hermitage Avenue during World War II. (Courtesy of Lottie Stegvilas Tervanis.)

Bill K's Liquors owners were William and Helen Kareiva. The store is seen here in 1945 at 4644 South Paulina Street. The liquor store was in front, and the tavern was in back with a horseshoe-shaped bar. Prior to opening Bill K's, the Kareivas owned Green Valley Products, a wholesale butter and egg business at the same location. When World War II began, it was difficult to get cheese and egg products. At the end of the war, the tavern took its place. (Courtesy of Marilyn Kareiva Zelasko.)

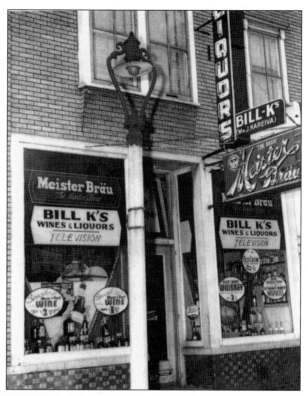

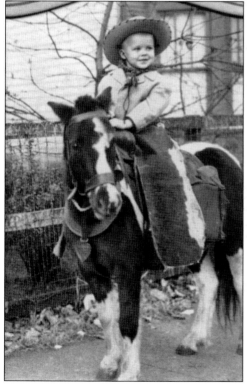

Michael Ezerski rides a horse in the vicinity of Forty-fifth Street and South Paulina Street in 1948 or 1949. A photographer used to come around the neighborhood with a horse and offer to take pictures. (Courtesy of Loretta Ezerski.)

Eleanore Wisinski Rumsa is pictured here at age 20 in the backyard of her home at 4715 South Elizabeth Street in the 1940s. (Courtesy of Roxanne Rumsa.)

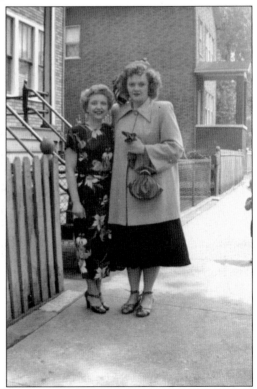

Frances Kolelis Kolling (left) and Emily Maka (a Sacred Heart Church parishioner) are seen here on the 1700 block of West Forty-fourth Street in 1949. (Courtesy of Carol Kolling Rickards.)

This photograph shows the 1946 wedding of Lottie Stegvilas and Bruno Tervanis at Holy Cross Church. Kathleen Jankowski is in the middle. (Courtesy of Lottie Stegvilas Tervanis.)

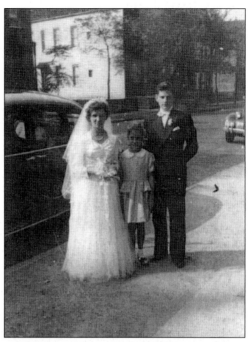

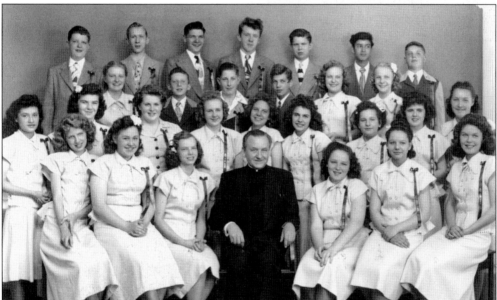

The Holy Cross Grammar School's class of 1948 poses here with Rev. Anicetus M. Linkus. They are, from left to right, (first row) Judith Metricks, Aidona Kuzavynas, Loretta Ezerski, Joan Lukas, Yvonne Therese, and Marlene Traksel; (second row) Anne Costello, Joan Jvarsky, Bernardine Kauffmann, Alvira Kanis, Arlene Stulginskas, Geraldine Burdginski, Adele Lukianskis, Mary Ann Yardas, and Connie Kudirka; (third row) Noreen Galvin, Anthony Acas, Edward Turas, Bernard "James" Kopulos, Hortense "Ticki" Nemunas, and Clara Urban; (fourth row) Frank Alexander, Richard Kanis, Armond Merlin, Theodore Zinkiewicz, Ronald Cervic, Raymond Aguilar, and Gordon Bormus. Irene Legner and Ruth Williams are not pictured. (Courtesy of Marlene Traksel Feldhaus.)

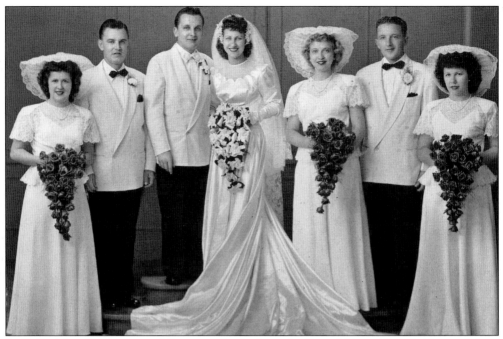

In 1949, Adam Kolelis married Bernice Wenskoski at the Sacred Heart Church. Pictured, from left to right, are Irene ?, possibly Ed Wenskoski, Adam Kolelis, Bernice Wenskoski, Frances Kolling, William "Duke" Kolelis, and Lil ?. (Courtesy of Carol Kolling Rickards.)

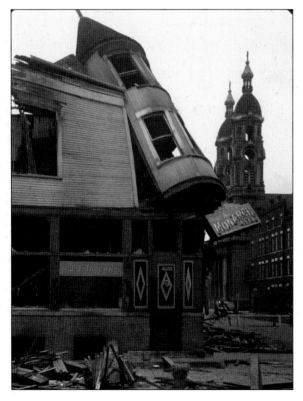

This photograph by Charles W. Cushman on January 16, 1949, shows the ruins of the wood frame corner saloon J. J. Tavern at 4600 South Paulina Street. The tavern once belonged to the Ezerski family. (Courtesy of Indiana University Archives [P4165].)

Mrs. John Martinkus owned a grocery store at 4516 South Hermitage Avenue (on the west side of street) in the 1950s. The neighborhood was a network of community ties. Martinkus greeted young moms with sandwiches and watched their babies. (Courtesy of Lottie Stegvilas Tervanis.)

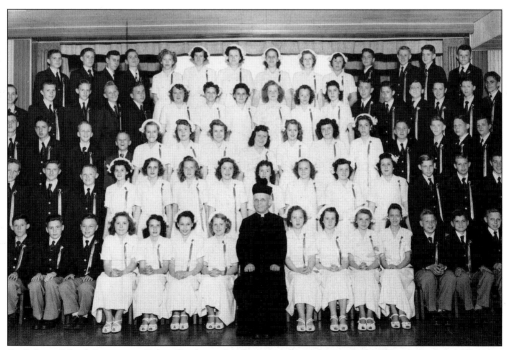

St. John of God Grammar School's class of 1950 poses for a photograph. (Photograph by Chicago Lawn Photos, courtesy of the Back of the Yards Neighborhood Council.)

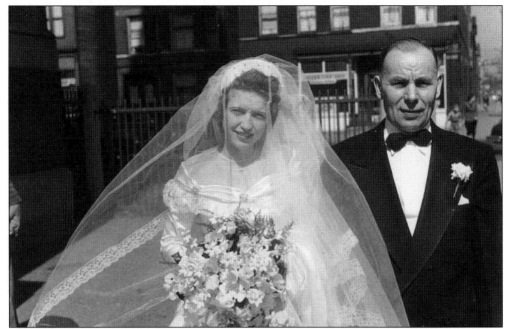

New bride Frances (Kolelis) Kolling poses with her father, Boleslovas Kolelis, outside Holy Cross Church on West Forty-sixth Street in 1950. The 4600 block of South Hermitage Avenue is in the background. (Courtesy of Carol Kolling Rickards.)

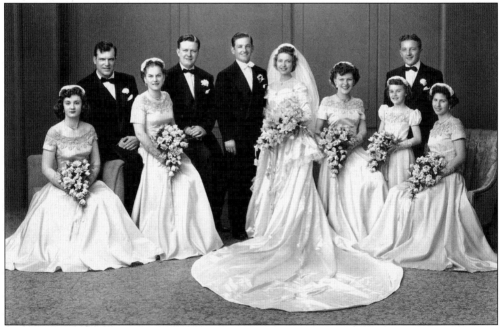

Peter Kolling and Frances Kolelis were married in 1950. Pictured, from left to right, are Ann Roza (bottom), "Pookie," Stephanie Stakas, Joe Stakas, groom Peter Kolling, bride Frances Kolelis, Bernice Silka, Loretta Sakal, Duke Kolelis, and Barbara Kolling. Stephanie and Joe Stakas were the owners of the Character Inn at 4600 South Marshfield Avenue. The wedding reception was held at White City Hall at 4759 South Throop Street. (Courtesy of Carol Kolling Rickards.)

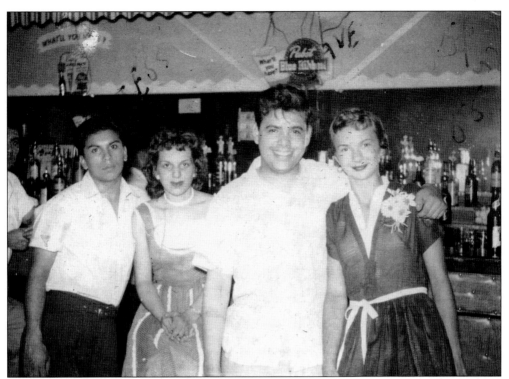

Jesse Chico, Jacqueline Kopulos, Dave Rodriguez, and Connie Jvarsky, from left to right, are out on the town in the 1950s. (Courtesy of Connie Jvarsky.)

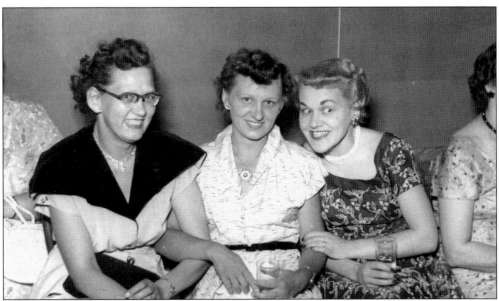

Pictured partying at a Ciburis family wedding in the 1950s are, from left to right, Josephine Stasulis, Lottie Stegvilas Tervanis, and Bernice Norkus Trump. (Photograph by Al's Candid Photos, courtesy of Lottie Stegvilas Tervanis.)

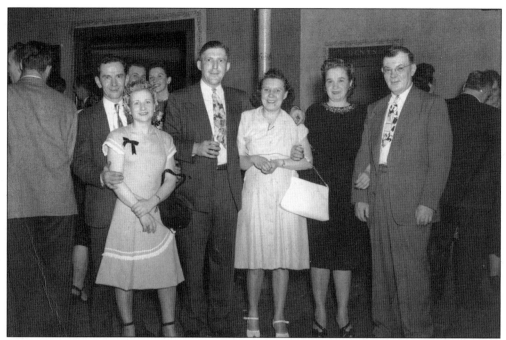

This wedding reception was held in the neighborhood in the early 1950s. In attendance were, from left to right, Tony and Stephanie Acas, an unidentified couple, and Stephanie and John Jvarsky (4500 South Hermitage Avenue block captain). (Courtesy of Connie Jvarsky.)

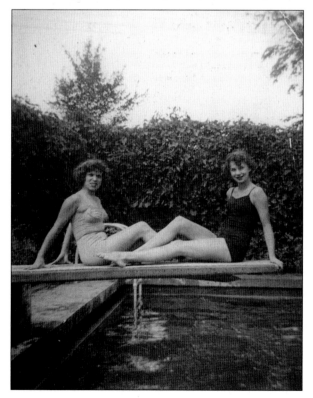

The McDowell Settlement House hosted a summer camp program at Camp Farr, located near Chesterton, Indiana. Jackie Kopulos (left) and Connie Jvarsky check out the swimming pool in the 1950s. (Courtesy of Jackie Kopulos Chico.)

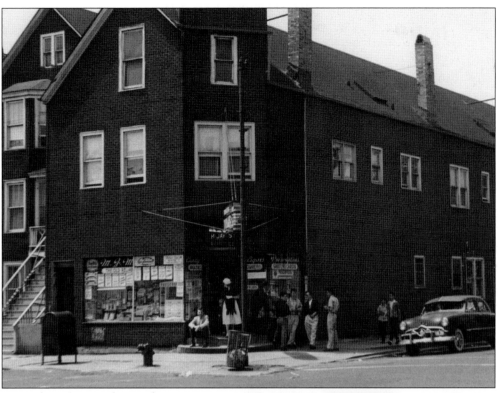

Located at 4500 South Wood Street, Mankowski's Drug Store is seen here in 1959. It was owned by M. J. Mankowski, who is featured in front of the store's magazine rack near a sign announcing: "We do not sell indecent books or magazines." (Courtesy of the Back of the Yards Neighborhood Council.)

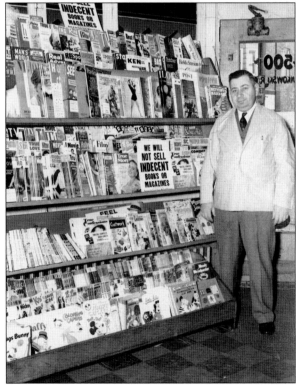

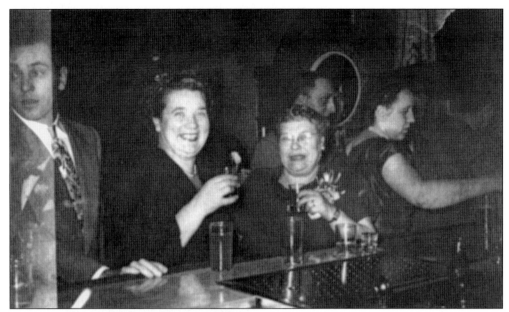

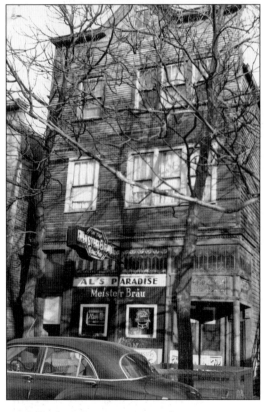

Roxanne Rumsa's christening was celebrated at Al's Paradise in 1956. Attending were, from left to right, unidentified, godmother Valeria, grandmother Elena Rumsa, Ray Wisinki, Florence Wisinski, and Leonard Wisinski. Al's Paradise was located at 4509 South Paulina Street and was owned by F. K. Rumsa. (Courtesy of Roxanne Rumsa.)

This Stack family Christmas card from the late 1950s features Frank and Jean and their children, from left to right, Candace, Cynthia, and Caryn. The Stacks lived on the 4600 block of Hermitage Avenue. (Courtesy of Lottie Stegvilas Tervanis.)

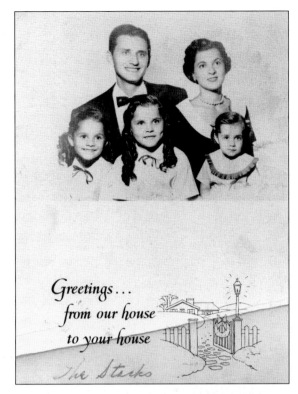

Greetings...
from our house
to your house

The Stacks

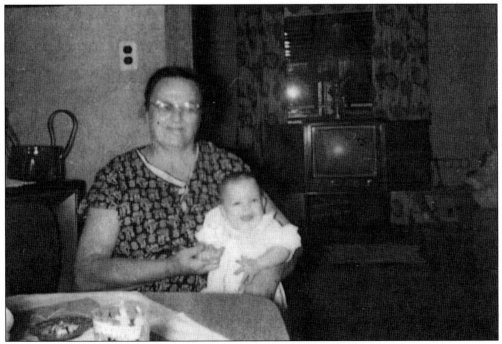

Roxanne Rumsa is seen here with her grandmother Katherine Wisinski in 1956 at 4800 South Ada Street. The man on the far right is her grandfather Leo Wisinski. They might have had two televisions back in 1956, but only one worked. (Courtesy of Roxanne Rumsa.)

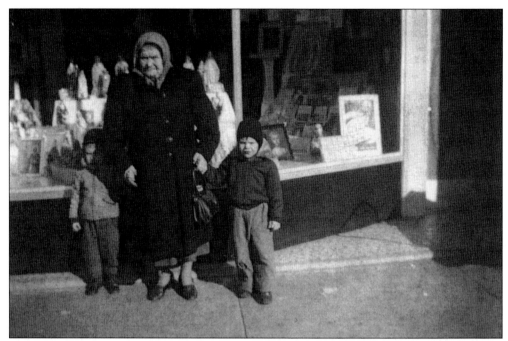

Bob Rumsa (left) and Donald Dulatis are pictured here with their grandmother Elena Rumsa in front of the church store on the 4500 block (east side) of South Ashland Avenue in 1957. (Courtesy of Roxanne Rumsa.)

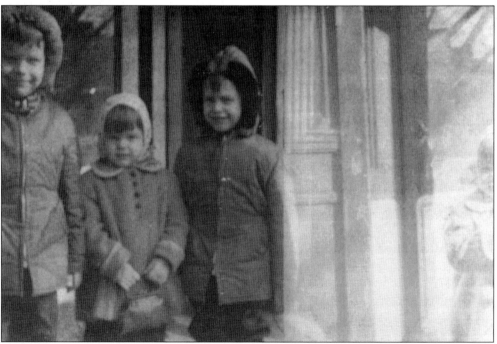

From left to right, Bob, Roxanne, and Al Rumsa are in front of their parent's tavern and home at 4509 South Paulina Street in 1959. (Courtesy of Roxanne Rumsa.)

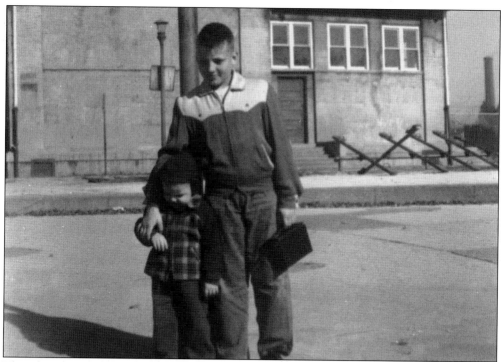

This photograph shows Tom Tervanis (left) and Tommy Vaiviatas visiting Davis Square Park in 1958 with a teeter-totter in the background. (Courtesy of Lottie Stegvilas Tervanis.)

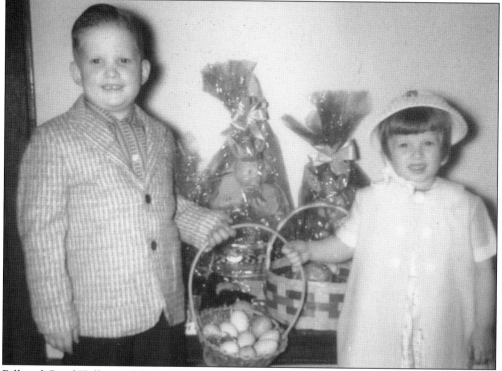

Bill and Carol Kolling celebrate Easter in 1959. (Courtesy of Carol Kolling Rickards.)

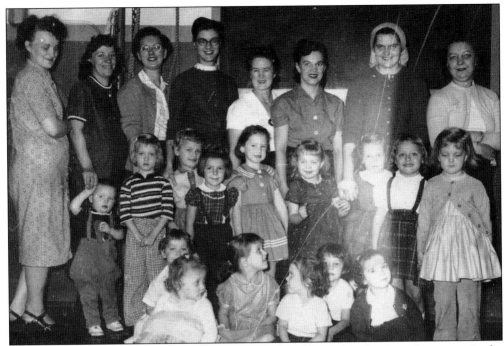

Emily Swist, in the middle of the third row in the white blouse; her daughter, Jeannette, in the middle row, fifth from left; and Wanda Mankowski, in the middle row fourth from left, are in the field house at Davis Square Park in 1959. (Courtesy of Jeannette Swist.)

This is the original program guide for the 1950s spring show, Dance with the Flowers, at the Holy Cross Grammar School, performed by the eighth-grade class. Connie Jvarsky was in the chorus and remembered going to the Zwarycz Coopershop barrel shop at 4550 South Laflin Street to buy metal barrel rings to hold and decorate the flowers she danced with. (Courtesy of Connie Jvarsky.)

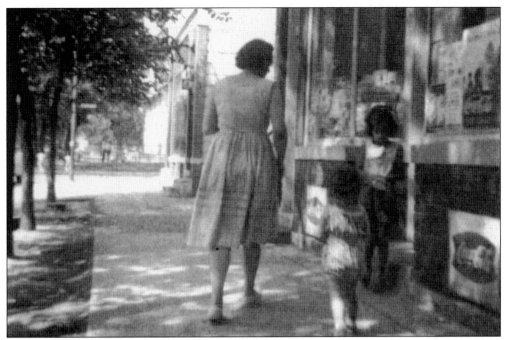

Mary Austin, who lived in one of the Rumsas' apartments at 4509 South Paulina Street, walks with her daughter Vicky (age 3) and friend Doris (from 4512 South Paulina Street) to Pete's store at 4505 South Paulina Street in the late 1950s or early 1960s. (Courtesy of Roxanne Rumsa.)

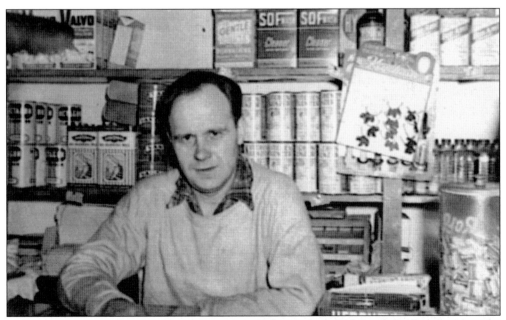

Grandpa Pete Martinkus is working the counter at his store at 4505 South Paulina Street in the late 1950s or early 1960s. His penny candy counter was very popular. In the summer, kids came in for candy, ice cream, and soda. Martinkus loved seeing the kids. (Courtesy of Caryn Olczyk.)

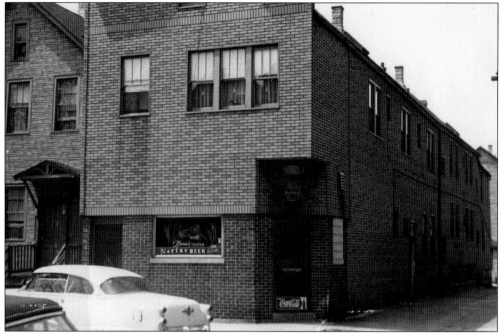

This tavern and residence at 4512 South Wood Street was owned by Telka Phillips. Ambrosia Brewing at 3700 South Halsted Street sold the "nectar beer" advertised. Many taverns also offered a hall to rent for social occasions. This photograph was taken in 1959. (Courtesy of the Back of the Yards Neighborhood Council.)

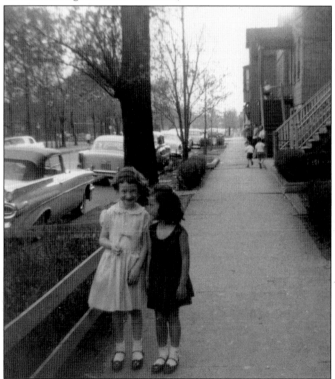

This photograph was taken on West Forty-fourth Street, between Marshfield Avenue and Paulina Streets, across from Davis Square Park in April 1960. The park provided open space to the wood tenements with narrow gangways between each building. Jeannette Swist (left) and Wanda Mankowski lived on the block. (Courtesy of Jeannette Swist.)

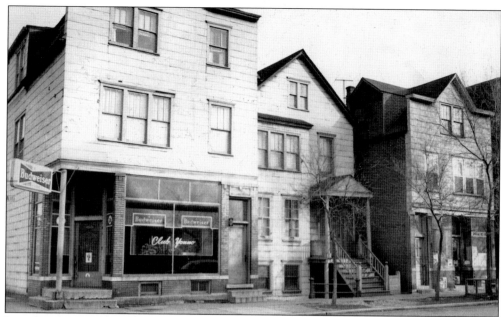

In earlier days, one was fortunate if there was hot water or a tub in a residential flat. For cold-water flats, a large galvanized tub was used for bathing. The water was heated from a pot on the stove to fill up the tub. Other bathing choices were the public park field house showers, which had separate private facilities for men and women, or the public bathhouses in the neighborhood. This 1962 photograph shows 4501 South Paulina Street with the saloon on the corner. The Paulina Turkish Baths was right around the corner at 1657 West Forty-fifth Street. A 1954 advertisement featured ultra violet, sunshine, and infrared light radiations; Swedish massage and movements; electric baths; and rooms for $3.50. Ladies' Day was Wednesday. (Courtesy of the Back of the Yards Neighborhood Council.)

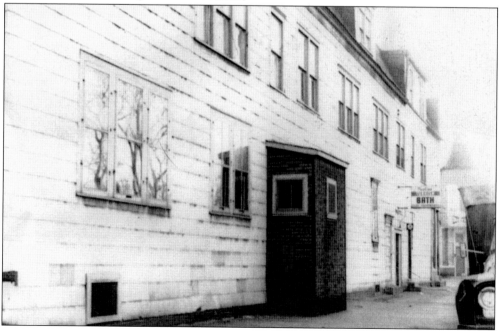

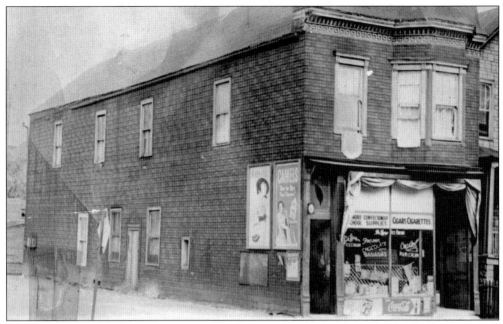

This storefront was located at 4603 South Honore Street in 1963. Gerri Walski Lozuk remembers this store for its delicious chocolate frozen bananas. (Courtesy of the Back of the Yards Neighborhood Council.)

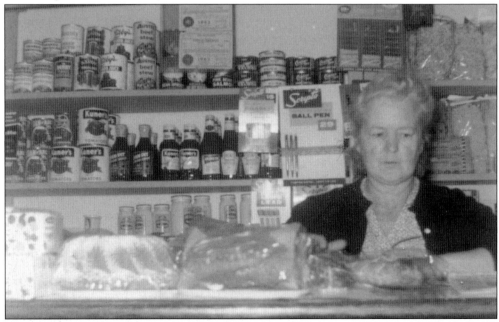

Emily Druktenis Swist works the counter at Ann Hartel's store on the corner of Forty-fourth Street and South Paulina Street across from Davis Square Park in this photograph from October 1963. Emily and many of her neighbors spoke more than one language in order to communicate with other ethnic groups. Kids from the neighborhood bought penny candy, paddleballs, wooden airplanes, tops, cold bottles of soda, Hawthorn Melody ice cream (in the cups with the wooden spoon), popsicles, and Mister Freezes. (Courtesy of Jeannette Swist.)

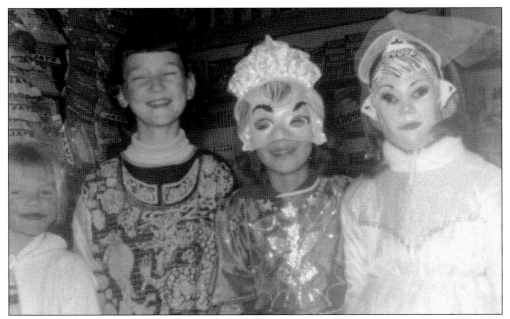

On Halloween in 1963, the neighborhood children trick-or-treat at Ann Hartel's store on the corner of West Forty-fourth Street and South Paulina Street. Pictured, from left to right, are Susie Nowakowski, Jeannette Swist, Wanda Mankowski, and Christine Piper. After trick-or-treating, Davis Square Park offered kids a break with movies, games, candy, and contests at the field house. (Courtesy of Jeannette Swist.)

Tom Tervanis celebrates his 1963 Holy Communion at home with relatives. Pictured, from left to right, are Barbara Boguslaw, Casmir Boguslaw, and Antoinette "Nancy" Boguslaw. (Courtesy of Lottie Stegvilas Tervanis.)

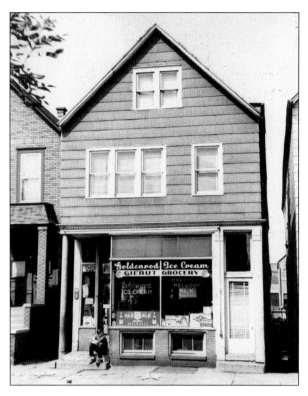

This early-1960s photograph shows Gierut's Grocery at 4530 South Honore Street. Proprietors were Andrew and Stella Gierut. Most owners lived in the same building as their grocery store or tavern/saloon. (Courtesy of the Back of the Yards Neighborhood Council.)

Stan's Bachelor's Club was located at 4622 South Honore Street and shared the location with apartments. There were saloons scattered throughout the community. Most blocks contained at least one saloon. (Courtesy of the Back of the Yards Neighborhood Council.)

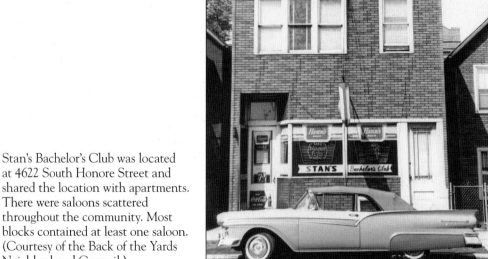

Alice Lach and Adolph Kupiec are in front of Kupiec's home at 4529 South Laflin Street in 1938. The bench in the background belonged to the Scribano family that resided at 4527 South Laflin Street. (Courtesy of Alice Lach Oskvarek.)

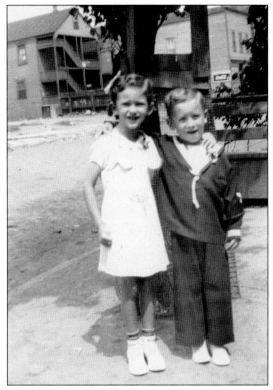

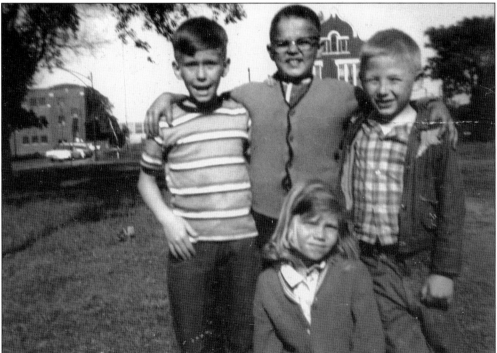

From left to right, John Mankowski, Mark Nowakowski, Donnie Maduza, and Susie Nowakowski (seated) are shown here in Davis Square Park in June 1966. (Courtesy of Jeannette Swist.)

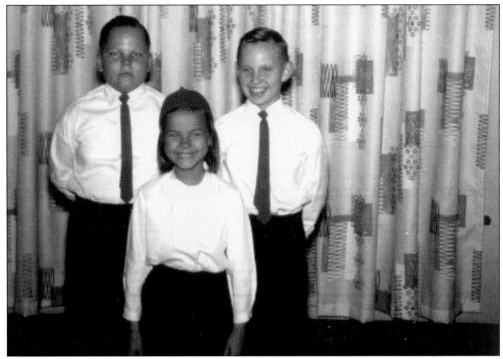

This was confirmation day for, from left to right, Charles Worbiew, Patrice Worbiew, and Tommy Tervanis in 1966. (Courtesy of Lottie Stegvilas Tervanis.)

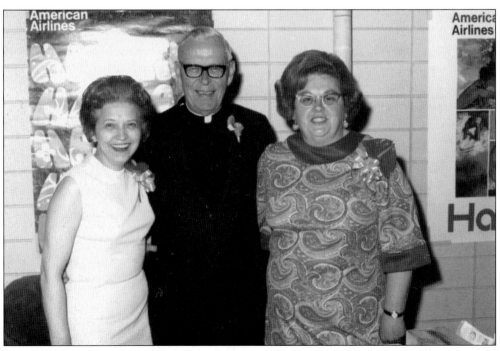

Rev. Adolph Stasys of Holy Cross Church is pictured here with Ladies Society officers Frances Kolling (left) and Bernice Dambraskas in the late 1960s. (Courtesy of Carol Kolling Rickards.)

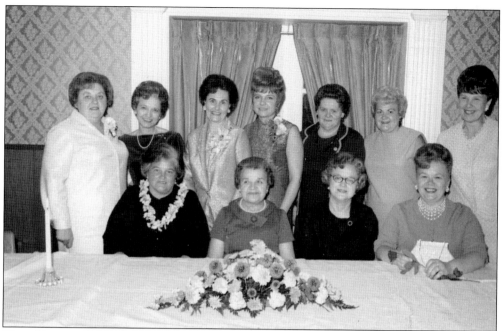

The officers are wearing corsages at this banquet for the Holy Cross Church Ladies Society in the 1960s. Pictured second from the left in the first row is Harriet Kuszlejko. Pictured from left to right in the second row are Bernice Dambraskas, Frances Kolling, unidentified, Adeline Jasaitis, Harriet Kaufmann, Emily Rusek, and unidentified. (Courtesy of Carol Kolling Rickards.)

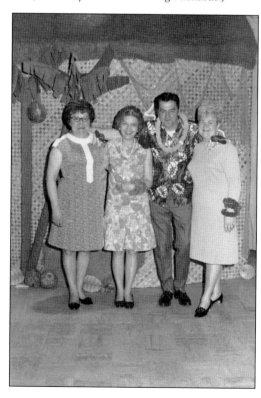

This is a fashion show for the Holy Cross Church Ladies Society in the 1960s. Pictured, from left to right, are Kay Norkus, Frances Kolling, Tom Dambraskas, and Emily Rusek. (Courtesy of Carol Kolling Rickards.)

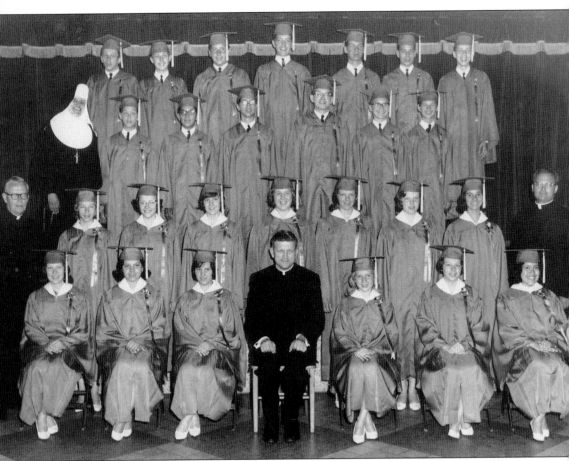

Seen here is the 1964 graduation at the Holy Cross Grammar School. Seated in the center of the first row is pastor Rev. Edward Abromaitis. Rev. Adolph Stasys is pictured in the second row, left, and Rev. Joseph Domeika is in the second row, right. In the third row is Sr. M. Scholastica. (Courtesy of David Schultz.)

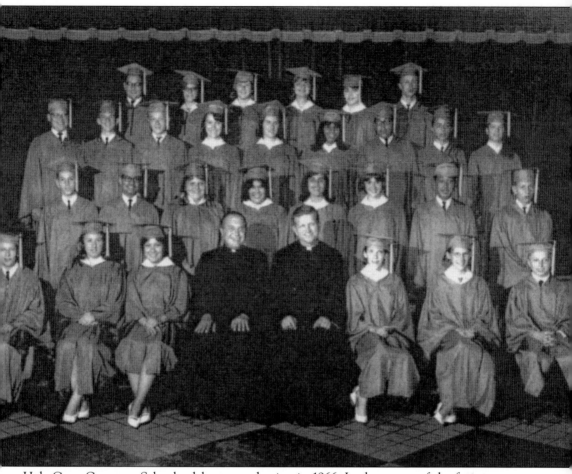

Holy Cross Grammar School celebrates graduation in 1966. In the center of the first row are Rev. Joseph P. Gilbert (left) and pastor Rev. Edward Abromaitis. (Courtesy of Cary Schultz.)

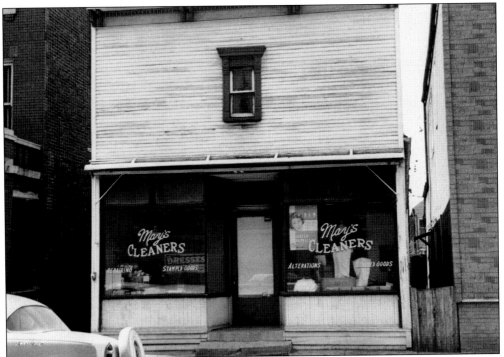

May's Cleaners was located at 4544 South Wood Street. (Courtesy of the Back of the Yards Neighborhood Council.)

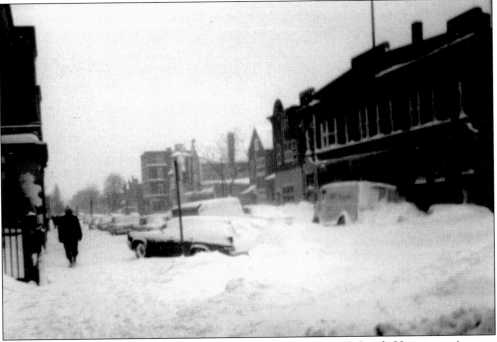

Seward school (left) and Rytina Baking Company, located at 4629 South Hermitage Avenue, are seen here during a 1967 snowstorm. Rytina later became Baltic Bakery. (Courtesy of Fred Symons.)

In the early 1900s, men pose in front of Lach Grocery and Meat Market at 4533 South Laflin Street. The second man from the left is Joseph Lattyak, who lived at 4524 South Laflin Street. The Lach Grocery store advertised in its window, "The Wilson label protects your table." The grocery store also promoted a punch card for each quart of grade A milk purchased. When the card was punched out, the customer would receive one gallon of grade A milk or one pint of cream free. The store carried Lake Valley Milk, "The Finest Under the Sun. Grade A. Fortified with Vitamin D, Chicago Health Department. Inspected." (Courtesy of Alice Lach Oskvarek.)

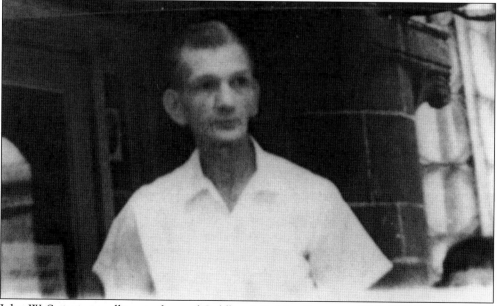

John W. Swist was walking in front of Goldberg's Fashion Forum at 4756–4758 South Ashland Avenue in the 1960s when someone snapped his picture. (Courtesy of Jeannette Swist.)

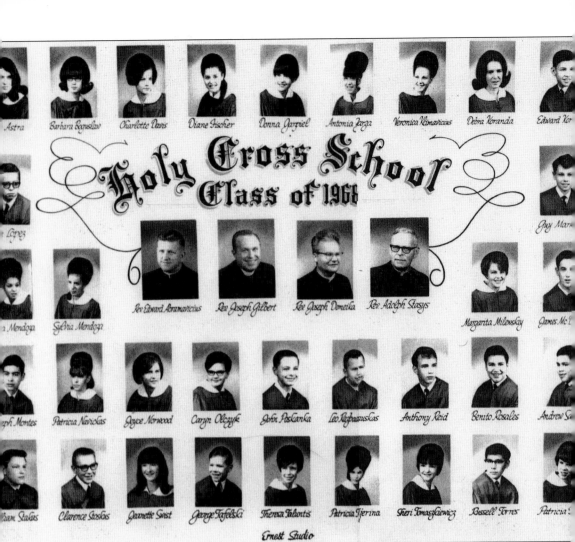

The Holy Cross Grammar School class of 1968 is shown here. (Courtesy of Jeannette Swist.)

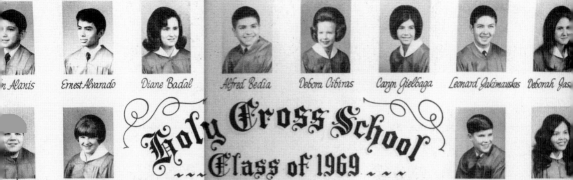

n Alanis    Ernest Alvarado    Diane Badal    Alfred Bedia    Debora Cibiras    Caryn Gielbaga    Leonard Jakimauskas    Deborah Jas

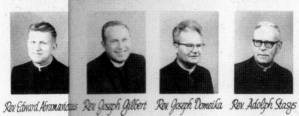

### Holy Cross School
### ⸻ Class of 1969 ⸻

n Kareiva    Carol Kolling                              James Koranda    Muriel Lo

s Mojarro    Joseph McDonnell    Rev. Edward Abramavicius    Rev. Joseph Gilbert    Rev. Joseph Domeika    Rev. Adolph Stasys    Liam McDonnell    Maria Men

e Phillips    Michael Pudzimas    Anthony Raso    David Raso    Philip Rodriguez    Letitia Rosales    Alfonse Rumsa    Thomas Terw

e Tomaszkiewicz    Maria Torres    Stephen Trinkle    Sylvia Urbano    Mario Valencia    Ruben Vega    Robert Williams    Charles Wort

Ernest Studio

Holy Cross Grammar School's class of 1969 is shown here. (Courtesy of Liam and Joe McDonnell.)

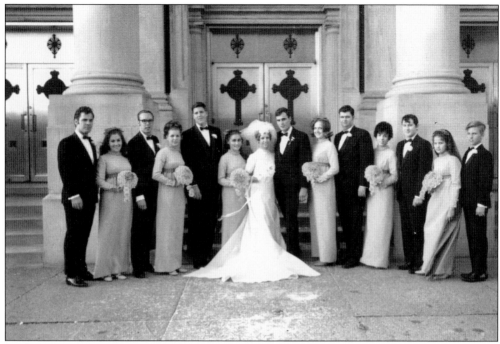

Bride Janet Tervanis and groom Bob Graeber are pictured here with their bridal party in front of Holy Cross Church on West Forty-sixth Street in 1969. (Courtesy of Lottie Stegvilas Tervanis.)

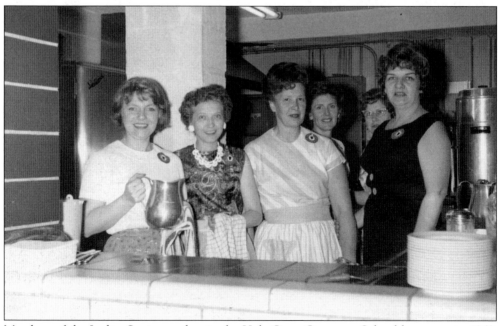

Members of the Ladies Society gather in the Holy Cross Grammar School basement in 1969. They are, from left to right, Adeline Jasaitis, Frances Kolling, unidentified, Irene Jasaitis, Eleanor Bernard, and Sylvia "Cece" Williams. (Photograph by Ernest Studio, courtesy of Carol Kolling Rickards.)

## *Two*

# BACK OF THE YARDS NEIGHBORHOOD COUNCIL

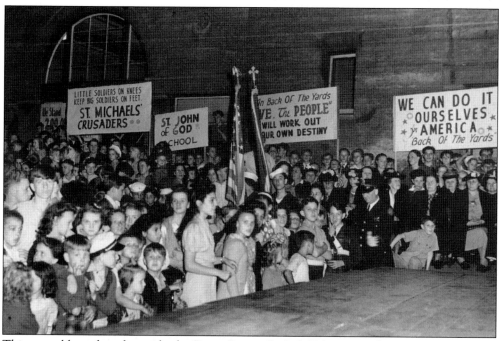

This assembly gathered outside the Davis Square Park field house in the 1930s. The banners representing St. Michaels Crusaders and St. John of God School feature the Back of the Yards Neighborhood Council slogan: "We the People Will Work Out Our Own Destiny, We Can Do It Ourselves America." Joseph B. Meegan and Saul D. Alinsky cofounded the Back of the Yards Neighborhood Council, the nation's first community organization. (Photograph by Bob Waidler, courtesy of the Back of the Yards Neighborhood Council.)

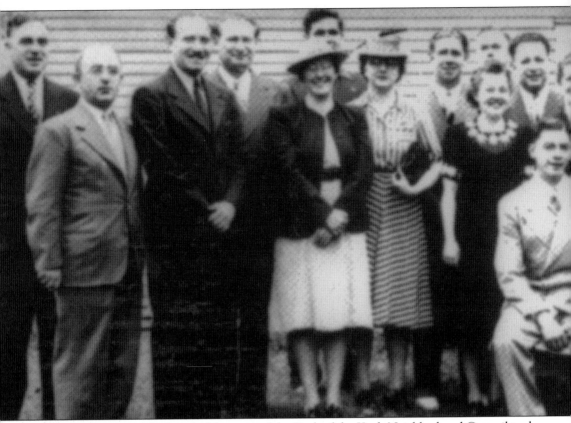

The first meeting of the board of directors of the Back of the Yards Neighborhood Council took place in 1939. The directors featured in this photograph include John Haffner and Aaron Hurwitz, copublishers of the *Back of the Yards Journal*; William A. Lewis, Lewis Clothing; Jacob Arkiss, Leader Laundry; Herbert March, Packinghouse Workers-Congress of Industrial Organizations (CIO); Isabell Goss, YWCA; Edward Wach, Davis Square Park; Jack Finn, president of the Back of the Yards Chamber of Commerce; William Kosmowski, Back of the Yards Businessmen's

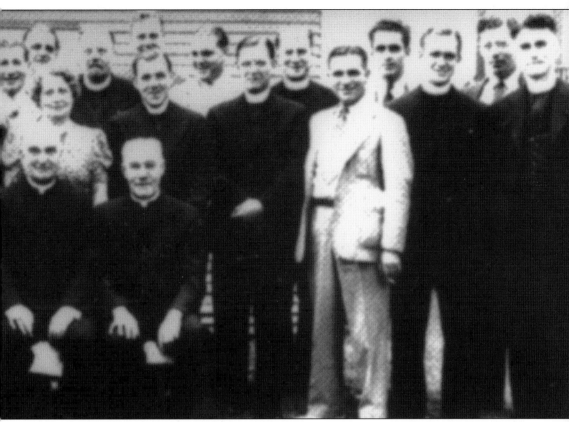

Association; archimandrite Timon Mullier, St. Michael's Russian Orthodox Church; Rev. Joseph Kelly, St. Rose of Lima; Joseph B. Meegan, cofounder; Sig Wlodarczyk, CIO; Rev. Ambrose Ondrak, OSB., St. Michael the Archangel Parish; Rev. Bernard Sokoloski, Sacred Heart Parish; Rev. Paul Dolenak, attorney; Saul D. Alinsky, cofounder; Rev. Stanley Valuckas, Holy Cross Parish; William Bonnetts, American Federation of Labor; Bishop Bernard J. Sheil; and Rev. Justin Kugelar, St. Augustine Parish. (Courtesy of the Back of the Yards Neighborhood Council.)

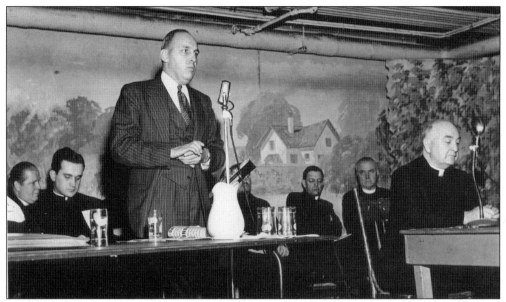

In 1939, Bishop Bernard J. Sheil (seated at desk) presided at the first community congress of the Back of the Yards council. Sheil was the founder of the Catholic Youth Organization (CYO) in 1930. The man sitting on the left is Fr. Roman J. Berendt, Sacred Heart Church. Pres. Joseph B. Meegan realized the key to unifying the diverse community was to speak to local priests, many of whom spoke several languages and all of whom influenced their congregation. (Photograph by R. E. Burgchardt, courtesy of the Back of the Yards Neighborhood Council.)

The St. Augustine Church was represented at the table for the Back of the Yards Neighborhood Council in 1939. (Photograph by the Chicago Park District, courtesy of the Back of the Yards Neighborhood Council.)

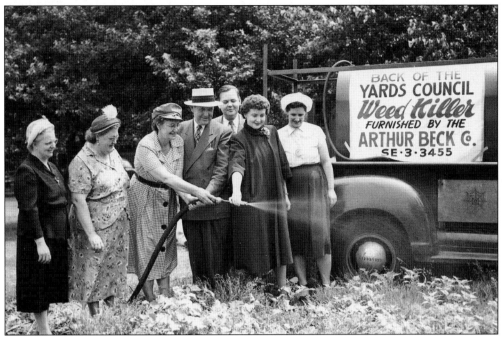

To abate ragweed, the Back of the Yards Neighborhood Council sprayed 231 vacant lots during the 1940s. Weed filler was furnished by the Arthur Beck Company. Note the spider logo on the truck's side door panel. (Courtesy of the Back of the Yards Neighborhood Council.)

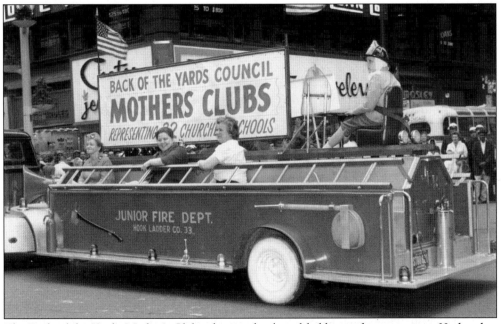

The Back of the Yard's Mother's Club rides in a hook and ladder truck representing 22 churches and schools in the State Street parade. (Courtesy of the Back of the Yards Neighborhood Council.)

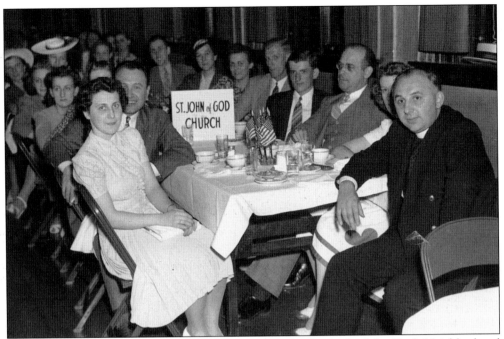

St. John of God Church was represented at the table for the Back of the Yards Neighborhood Council in 1939. Msgr. Edward Plawinski sits at the head of the table. (Courtesy of the Back of the Yards Neighborhood Council.)

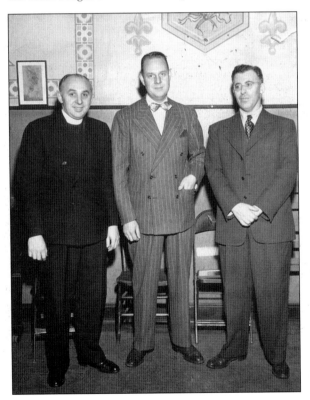

St. John of God Church pastor Msgr. Edward Plawinski and Back of the Yards Neighborhood Council cofounders Joseph B. Meegan (center) and Saul D. Alinsky are pictured here in the early 1940s. (Courtesy of the Back of the Yards Neighborhood Council.)

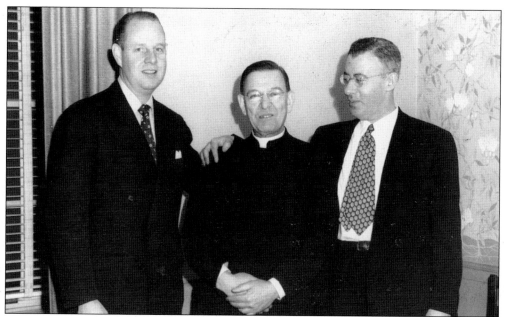

Joseph B. Meegan (left), Rev. Ambrose L. Ondrak, and Saul D. Alinsky are pictured here on the day of the presentation of the pectoral cross to Ondrak of St. Michael the Archangel Church. Meegan had an unbelievable ability to charm friends and enemies alike. He would always say, "You can only win through conversation and you can only lose through confrontation." (Courtesy of the Back of the Yards Neighborhood Council.)

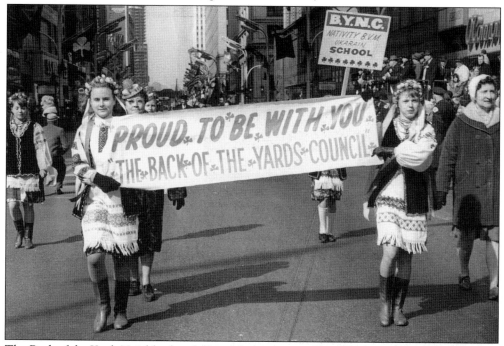

The Back of the Yards Neighborhood Council is represented here by the Nativity Blessed Virgin Mary Ukrainian School in a downtown parade in the 1960s. (Courtesy of the Back of the Yards Neighborhood Council.)

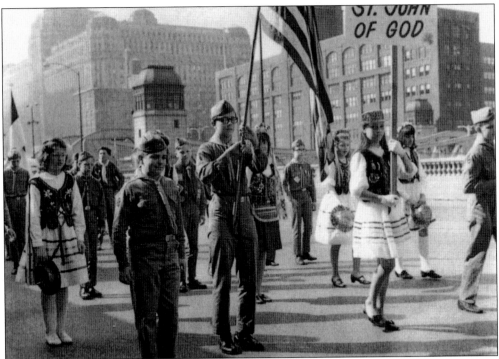

The Back of the Yards Neighborhood Council is represented by St. John of God in a downtown parade in the 1960s. (Courtesy of the Back of the Yards Neighborhood Council.)

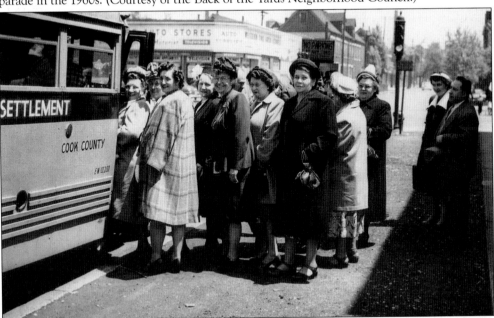

The Back of the Yards's Mother's Club boarding settlement bus sits at the southwest corner of Forty-sixth Street and South Ashland Avenue. This view is from West Forty-sixth Street looking east with an auto parts store on the northeast corner across the street on South Ashland Avenue. The Back of the Yards Neighborhood Council organized 34 Mothers Clubs to sponsor educational and health programs. (Courtesy of the Back of the Yards Neighborhood Council.)

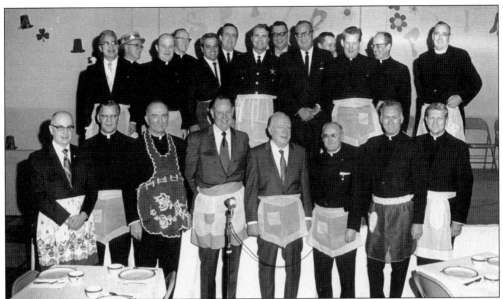

Back of the Yards Council men wearing aprons host a spring dinner for the sisters of the parish schools. Joseph B. Meegan is in the first row, fourth from the left. To Meegan's left is actor Pat O'Brien, and over O'Brien's left shoulder, the man with the glasses is Sonny Tufts, a great actor who was a friend of Meegan's and the Back of the Yards Neighborhood Council. On the far right, in the first row, is Fr. Edward Abromaitis of Holy Cross Church. (Courtesy of the Back of the Yards Neighborhood Council.)

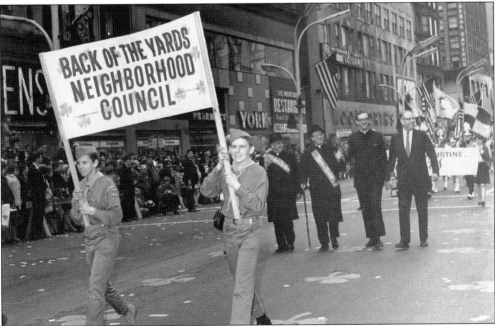

This Back of the Yards Neighborhood Council sign is being carried by Boy Scouts with dignitaries walking behind in the St. Patrick's Day parade on State Street in 1964. Meegan is on the far right. (Photograph by Cameramen, Incorporated; courtesy of the Back of the Yards Neighborhood Council.)

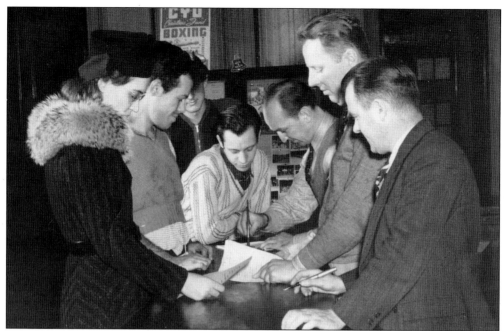

Joseph B. Meegan manages the CYO sign-up at Davis Square Park. The CYO's success came from its extensive and comprehensive sports programs. It worked to combat delinquency, Americanize ethnic Catholics, and bridge social divisions through a variety of programs. (Courtesy of the Back of the Yards Neighborhood Council.)

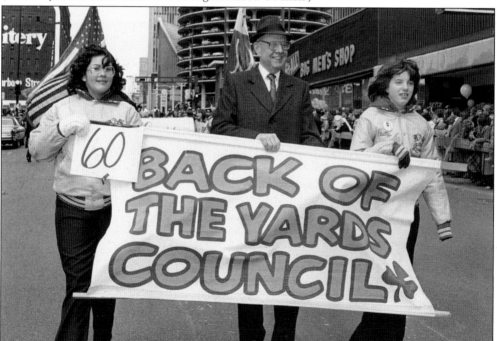

Meegan and two girls carry a Back of the Yards Neighborhood Council sign in the St. Patrick's Day parade on State Street. (Photograph by Murphy Photography Incorporated, courtesy of the Back of the Yards Neighborhood Council.)

# *Three*

# SHOP IN
# BACK OF THE YARDS

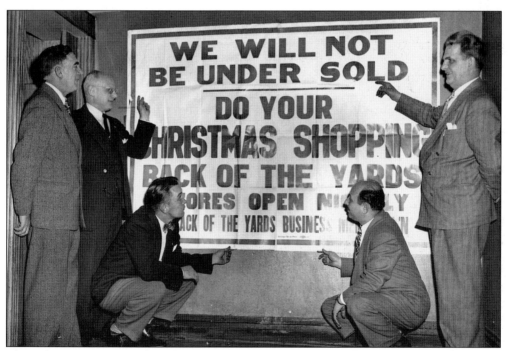

This advertisement was for Christmas shopping in the Back of the Yards neighborhood. (Courtesy of the Back of the Yards Neighborhood Council.)

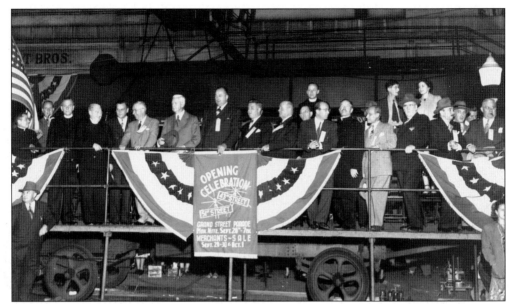

This 1942 Grand Street parade and opening celebration took place on Forty-seventh Street and South Ashland Avenue in front of Goldblatt Brothers Department Store. Dignitaries on the ceremony platform include Mayor Martin Kennelly (left of signage), Rev. Anicetus M. Linkus (third from left) of Holy Cross Church, and Joseph B. Meegan (behind Linkus). Notice how South Ashland Avenue was paved in brick with streetcar rail lines. (Courtesy of the Back of the Yards Neighborhood Council.)

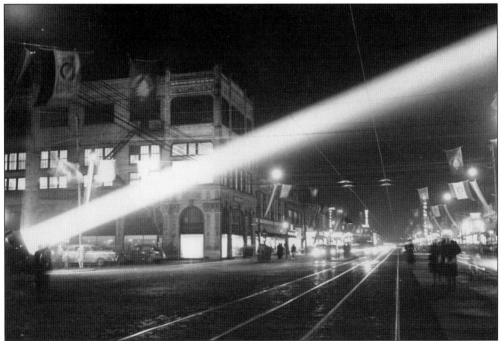

This is another 1942 view of South Ashland Avenue with the Forty-seventh Street intersection in view. Spotlights and stores aglow in lights along South Ashland Avenue make the streetcar tracks gleam in the night. (Courtesy of the Back of the Yards Neighborhood Council.)

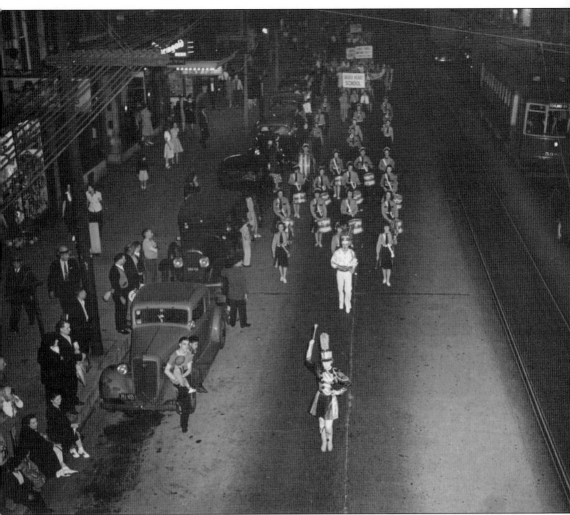

This parade traveled north on the 4600 block of South Ashland Avenue in 1942 with community organizations like Sacred Heart Church represented. Pictured, at top left, is the Olympia Theatre, which was located at 4619 South Ashland Avenue from 1917 to 1950. The movie featured is *Son of Fury*. A streetcar is in operation to the right in the photograph. The Olympia was part of the Schoenstadt chain of theaters, and it seated 582. In 1950, a neighboring store expanded into the space. (Courtesy of the Back of the Yards Neighborhood Council.)

In 1947, the Back of the Yards council met and organized the Back of the Yards Businessmen's Association to promote business in local stores. A significant group of entrepreneurs served the community. These businesses included Goldblatt Brothers Department Store, Meyer Brothers department store, William A. Lewis, Rhein's Jewelers, Iglow Jewelers, Syrena Restaurant, Brabec's Department Store, Town of Lake Utilities, and so on. (Photograph by R. E. Burgchardt, courtesy of the Back of the Yards Neighborhood Council.)

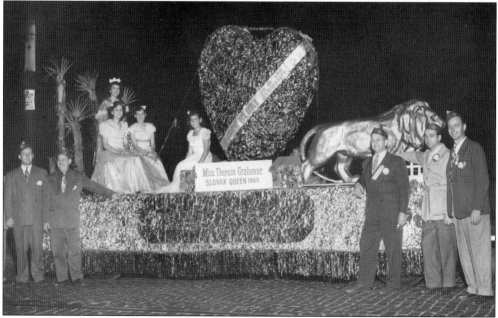

The 1949 parade featured the Lions Club float entry "Heart is in our Community," with Slovak Queen Therese Grahovec on board. (Courtesy of the Back of the Yards Neighborhood Council.)

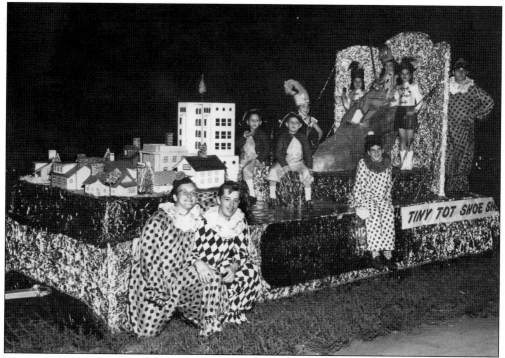

This undated photograph shows the Pierzynski Tiny Tot Shoe parade float. Pierzynski Tiny Tot Shoe Store was located at 1720 West Forty-seventh Street. (Courtesy of the Back of the Yards Neighborhood Council.)

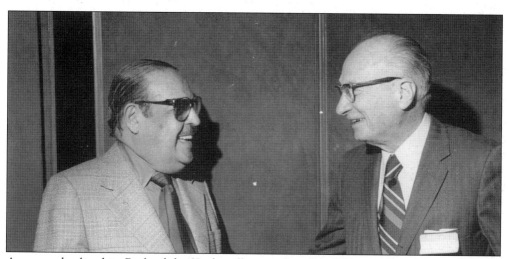

Anyone who lived in Back of the Yards will remember the children selling boxes of World's Finest Chocolate bars for school fund-raising activities. In the 1960s, the bars were sold at 50¢ each. Seen here are L. Joel Goldblatt of Goldblatt Brothers Department Store (left) and R. Edward Opler, president of World's Finest Chocolate. (Courtesy of the Back of the Yards Neighborhood Council.)

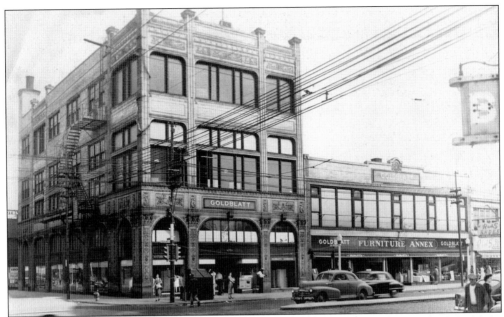

The Goldblatt Brothers Department Store furniture annex was in the former state bank building, pictured here at the southeast corner of Forty-seventh Street and South Ashland Avenue in the 1950s. Four major banks that served the neighborhood began to close in 1932 as a result of the Great Depression, including this former state bank building. (Courtesy of the Back of the Yards Neighborhood Council.)

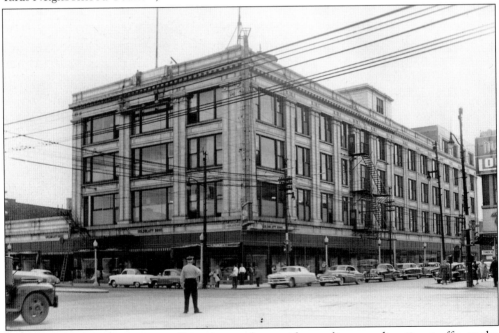

Goldblatt Brothers Department Store is seen here with a policeman directing traffic at the southwest corner of Forty-seventh Street and South Ashland Avenue in the 1950s. Goldblatt's was advertised as "America's fastest growing department stores." (Courtesy of the Back of the Yards Neighborhood Council.)

Dignitaries enter the doors at the grand opening of Goldblatt Brothers Department Store's newly remodeled store at Forty-seventh Street and South Ashland Avenue in the late 1950s or early 1960s. (Courtesy of the Back of the Yards Neighborhood Council.)

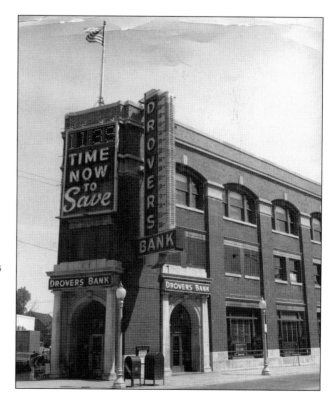

Drovers National Bank is pictured here at Forty-seventh Street and Ashland Avenue in the 1960s. Drovers's "Time Now to Save" clock and temperature gauge were Back of the Yards landmarks. The bank's first home was in a brownstone at 4191 South Halsted Street. It opened in 1883 and celebrated its 100th birthday on February 12, 1983. In 1978, it joined the Cole-Taylor Financial Group. Subsequently, the building on Forty-seventh Street was razed and a Cole-Taylor Bank is on its site. (Courtesy of the Back of the Yards Neighborhood Council.)

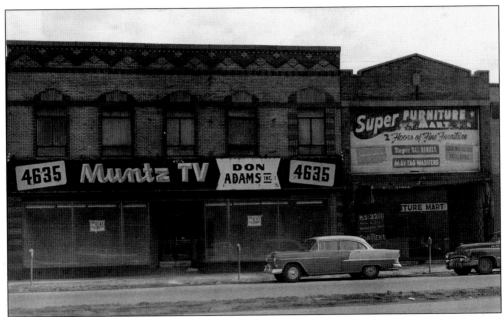

This photograph is of Muntz TV, founded by Earl William "Madman" Muntz, at 4635 South Ashland Avenue in the late 1950s. Muntz's motto was "I buy 'em retail and sell 'em wholesale." He was famous for introducing an affordable television set in Chicago. (Courtesy of the Back of the Yards Neighborhood Council.)

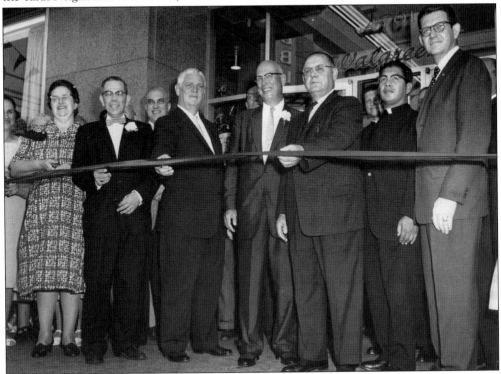

This 1960 Walgreens ribbon-cutting ceremony was held at the store on the corner of Forty-seventh Street and South Ashland Avenue. (Courtesy of the Back of the Yards Neighborhood Council.)

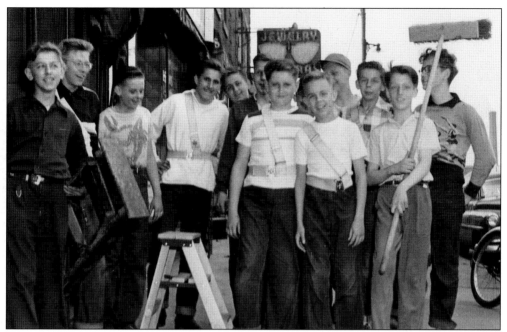

Outside Iglow Jewelers on the 4600 block of South Ashland Avenue, a crew of unidentified boys with brooms and stepladders wear crossing guard safety belts while working on a street-cleaning program. (Photograph by Douglas-Kuehnke Photographers, courtesy of the Back of the Yards Neighborhood Council.)

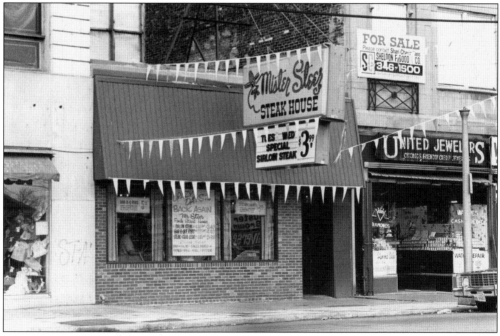

This photograph is of the Mister Steer Steak House on the 4700 block of South Ashland Avenue on the west side of street next to the toy store in the early 1970s. (Courtesy of the Back of the Yards Neighborhood Council.)

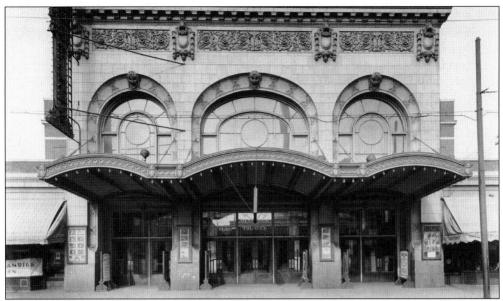

Designed by Rapp and Rapp, architects of the Chicago Theatre, the People's Theatre at 1616–1624 West Forty-seventh Street originally featured a triple-arched gateway, distinctive terra-cotta, and art moderne and classical styles. It seated nearly 2,400 and featured a balcony and a 2/6 Wurlitzer organ. In its early days, it hosted vaudeville and musical stage acts. It was part of the Schoenstadt chain, and in the 1960s, it hosted many onstage appearances, as well as movies. Sonny and Cher and the Dave Clark Five appeared here. In the late 1930s, Gertie's Candy Shop was located at 1624 West Forty-seventh Street on the corner of Marshfield Street. In the 1960s, it was Gus's Snack Shop. Later the theater was subdivided into several small clothing stores before being razed. Today a Walgreens is on the site. (Courtesy of American Terra Cotta Company, Records, Northwest Architectural Archives, University of Minnesota Libraries, Minneapolis, Minnesota.)

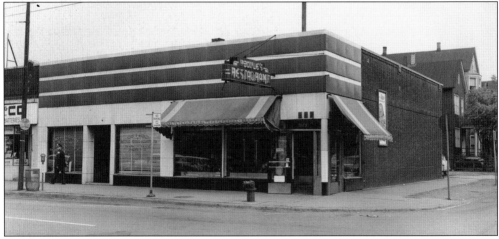

People's Restaurant was located half a block west of the theater at 1628 West Forty-seventh Street at Marshfield Avenue. The restaurant was opened in 1937. Another popular restaurant to dine at was Jucus Sisters Restaurant, located a half block east of the theater at 1608 West Forty-seventh Street. It advertised in the *Back of the Yards Journal*, "Good food always at moderate prices." (Courtesy of the Back of the Yards Neighborhood Council.)

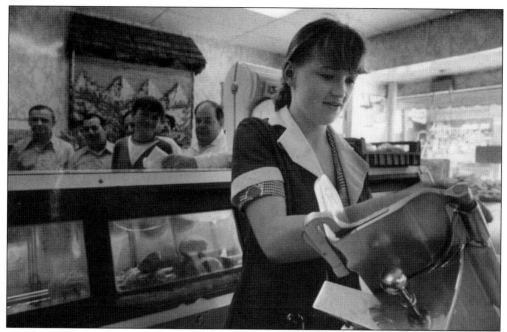

Bobak's Store's first location was on West Forty-seventh Street (between Marshfield Avenue and Paulina Street on the north side). Walter Kozial, manager of Cimino Liquors, is at the counter waiting for his order in the 1960s. (Photograph by M. Leon Lopez, courtesy of the Back of the Yards Neighborhood Council.)

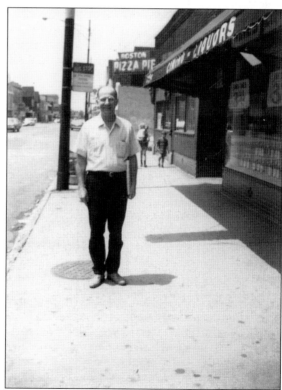

Clarence J. Stoskus Sr. is walking along Forty-seventh Street by Paulina Street in the 1960s. Boston's Pizza Pie store is at the corner of Paulina Street, and Cimino Liquors is on the right. (Courtesy of Clarence J. Stoskus Jr.)

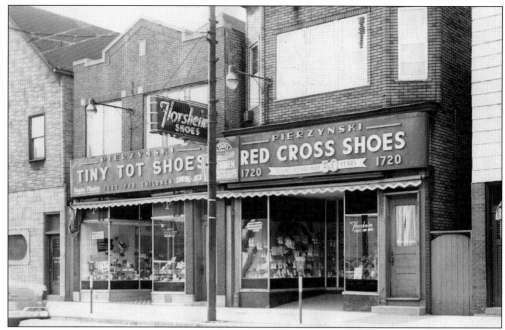

The Pierzynski Tiny Tot Shoes and Red Cross Shoes are seen here at 1720 West Forty-seventh Street in the early 1960s. Carol Navickas Wajda remembered the store's foot X-ray machines where customers could see how shoes fit on their feet. Jack's Store on West Forty-seventh Street also had a foot X-ray machine. (Courtesy of the Back of the Yards Neighborhood Council.)

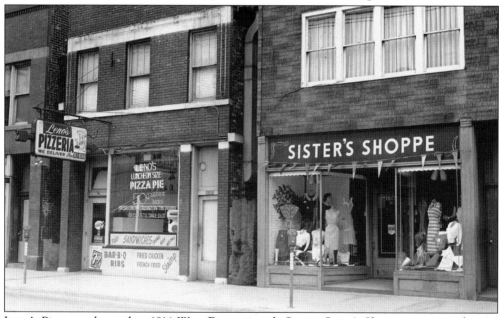

Leno's Pizza was located at 1814 West Forty-seventh Street. Sister's Shoppe was next door at 1817 West Forty-seventh Street and gave out Sperry and Hutchinson (S&H) green stamps. This photograph was taken in the early 1960s. In 1954, neighbors might have shopped at another store on the block, Metricks Farm Food Store at 1804 West Forty- seventh Street. (Courtesy of the Back of the Yards Neighborhood Council.)

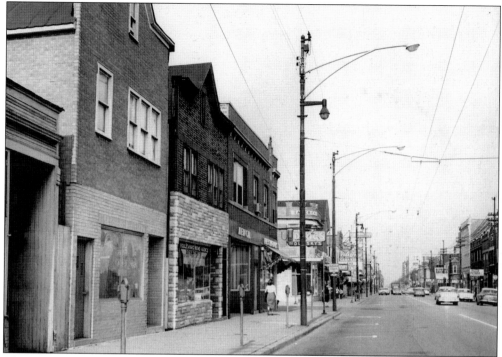

This street view shows storefronts along Forty-seventh Street looking east. Dubsky's Drug Store is on the northeast corner (left) in the 1960s. (Courtesy of the Back of the Yards Neighborhood Council.)

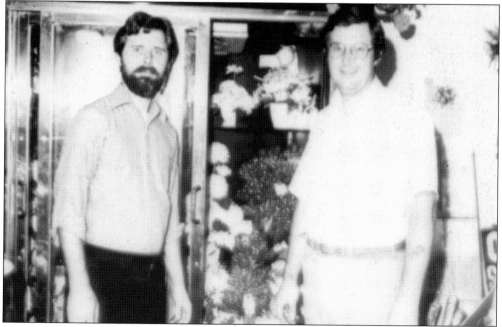

Martin's Floral Shoppe's florist, Ray Martin (right), is pictured here with his brother Leonard in front of a display case. The store was located at 1834 West Forty-seventh Street. (Courtesy of the Back of the Yards Neighborhood Council.)

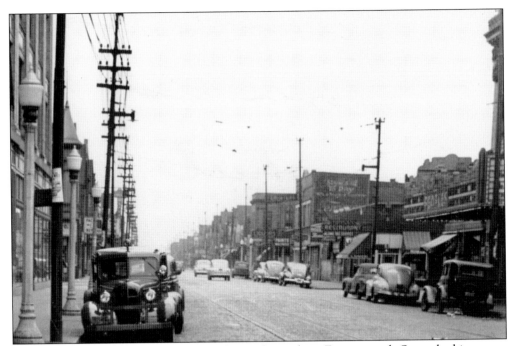

This street view shows storefronts and electric lines along Forty-seventh Street looking west. People's Theatre is on the right, Goldblatt Brothers Department Store is on the left. (Courtesy of the Back of the Yards Neighborhood Council.)

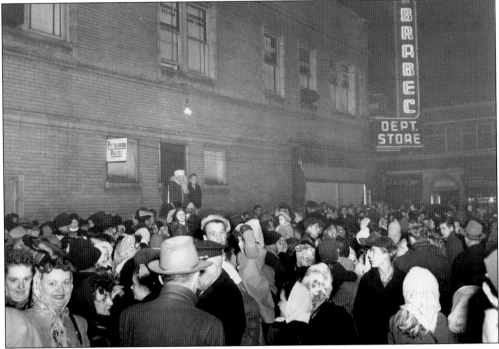

Brabec's Department Store, "leader of low prices," at 2001–2011 West Fifty-first Street attracts crowds of onlookers to see Santa during Christmas holidays. (Courtesy of the Back of the Yards Neighborhood Council.)

# *Four*

# STOCKYARDS

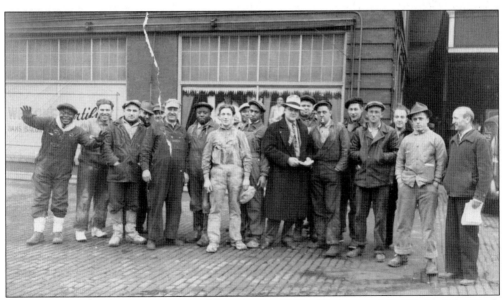

A union organizing activity is pictured here in the 1940s. (Courtesy of the Back of the Yards Neighborhood Council.)

# Swift Arrow

**Vol. XIV**  Swift & Company's Plant, Chicago, Ill., September 14, 1934  **No. 5**

## NEW PENSION RULE MAKES PROVISIONS FOR INTERRUPTIONS

### Length of Breaks Due to Lay-off Increases with Service of Employes

A question regarding pension service which has been in the minds of many employes of Swift & Company and has been raised by at least three plant assemblies was answered August 15 by the secretary of the pension board. Within certain limits, breaks in service due to lay-off will not terminate an employe's eligibility for pension here after.

According to the announcement, employes who are discharged for cause, or who quit the service of the company voluntarily, sacrifice their pension privileges. Such employes, provided they return to the employ of the company after having been discharged or quit voluntarily, will find their pension service beginning with their last date of hiring.

**No Termination for Lay-off**

A lay-off as the result of a reduction

## New Chicagoan

**J. L. Fike**

From the South Omaha, Nebr., organization came J. L. Fike, July 30 to take a position in the standards department at the Chicago plant following the transfer of W. H. Meyer to the general superintendent's office.

Mr. Fike entered the employ of Swift & Company at South Omaha nine years ago following his graduation from Iowa State College. He landed a job in the standards department, where,

## Mechanical Department
### R. Hughes

Joe Reuther has finally satisfied a supressed desire. He had a dog. Please note that we said *had*, not *has*.

Ralph Gantt came to work early one morning and along the way found a pooch (pedigree unknown and indeterminate). Ralph hid the dog away, thinking to take him home that night. Joe Reuther offered to take the dog home for him, to which Ralph agreed. Joe, however, took the pooch to his own home. Some days later Joe reported that the dog had run away.

So Ralph has lost a dog he never had and Joe has a dog that has run away. If you can figure it out you're a better man than we are, Gunga Din.

The mechanical department extends its sympathy to J. Murphy following the loss of his brother, Tom, who passed away in Hot Springs, Ark., August 28. Interment was in Chicago, August 31. The deceased was an employe of Swift & Company years ago.

Richard E. Stark announces the arrival in his home of an eight-pound, fourteen-ounce baby boy on August 22. And folks, believe it or not, the youngster looks just like Dick.

Dick was so happy over the blessed event that he promptly dubbed the young man Otto. So, instead of having only one happy man in the planning department, we have two, Dick Stark and Otto Yokum.

## He Ends Career

**James E. McDermott**

Since July 1 the hog killing department at the Chicago plant has been minus the services of one of the pioneers of the business, and much water will pass under the bridge before another will have become as well acquainted with pork dressing operations as James E. McDermott, known far and wide as just plain Ed.

Born February 17, 1872, Mr. McDermott joined the Swift & Company

## ASSEMBLY EFFORTS REWARDED; LIGHTS WILL BE INSTALLED

### Traffic Deaths on Ashland Avenue Will Be Reduced, Is Belief of Committee

After months of endeavor it appears that the Chicago plant assembly is about to win another decision. This time the case centers about traffic hazards on Ashland Avenue and has as its object the installation of stop-and-go lights at 41st and 42nd Streets, 42nd Place, and 43rd Street.

More than a year ago the safety committee became alarmed at the great number of people who were being killed or injured on Ashland Avenue as they attempted to cross the street in the face of heavy, rapidly moving traffic. Through the efforts of the safety committee the mayor of the city of Chicago was interested in the situation and saw to the location of traffic officers at 41st and 42nd Streets at rush hours.

**Death Toll Continues**

Accidents continued to occur, however, with the result that the assembly

The *Swift Arrow* was a newspaper for the Swift and Company's plant in Chicago. (Courtesy of Connie Scribano Kopulos.)

---

# WS ITEMS FROM HERE AND TH

### Two Veteran Builders Lay Aside Their Aprons, Rest on Pension

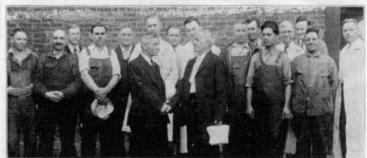

The picture shows Charles Wagner, left, and Joseph Ottaviano, right, congratulating each other at the time of their pension. Mr. Wagner and Mr. Ottaviano were each presented with a pipe, tobacco, and cigars by their fellow employes shown with them.

and came to this country in 1890 when he was 23 years old. He has been in the service for the past 32 years as a roofer. He can tell you about the erection and condition of every roof on the west end of the plant. He expects to spend the remainder of his

owns his home.

Mr. Ottaviano was born in Italy and came to this country in 1907, at the age of 37 years. He has been an employe of Swift & Company as a bricklayer helper for the past 27 years. He expects to spend his time at 4717

This article and photograph titled "Two Veteran Builders Lay Aside Their Aprons, Rest on Pension" features Emanuel Scribano (third from right, front) and Joseph Ottaviano, a friend of the Scribano family. (Courtesy of Connie Scribano Kopulos.)

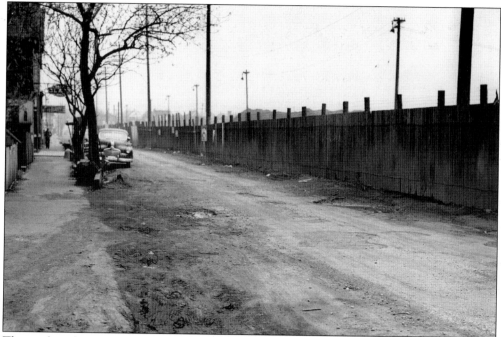

The stockyards fence alongside Armour and Company is seen here at Forty-fifth Street looking west to Ashland Avenue in the 1950s. The tavern is down the block on the left. (Courtesy of the Back of the Yards Neighborhood Council.)

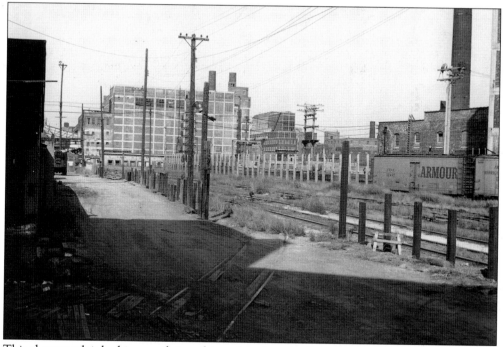

This photograph is looking north into the stockyards and rail yard with an Armour and Company railcar at 4500–4600 South Loomis Street. (Photograph by Creative Photography, courtesy of the Back of the Yards Neighborhood Council.)

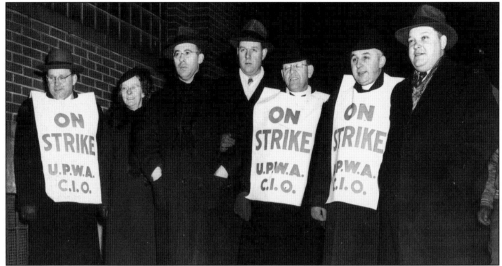

In 1946, the United Packinghouse Workers and CIO held a strike and formed a picket line in order to obtain better living wages for Union Stock Yard workers, most of whom lived in local parishes. Pictured, from left to right, are Pastor Herman Brauer, St. Martini Lutheran Church; Isabelle Gross of the YWCA; Saul D. Alinsky and Joseph B. Meegan, cofounders of the Back of the Yards Neighborhood Council; Abbott Ambrose Ondrak, St. Michael the Archangel parish; Msgr. Edward Plawinski, pastor of St. John of God Parish; and Sig Wlodarczyk, CIO. (Photograph by the Chicago Tribune, courtesy of the Back of the Yards Neighborhood Council.)

This Multigraph Department of Armour and Company is shown here in 1947. Pictured, from left to right, are Lucille, Amelia, Ethel, Ruth, Fran Kolelis, and Marie. (Courtesy of Carol Kolling Rickards.)

This 4501 South Laflin Street two-story tenement flat looks as if there was a store or tavern on the first floor. The building is adjacent to the stockyards near Armour and Company. The woman and young boy are leaving through the side entrance. The building was torn down in the 1950s. The Back of the Yards Neighborhood Council urged strict building code enforcement and compliance at weekly court hearings on housing and zoning violations. (Courtesy of the Back of the Yards Neighborhood Council.)

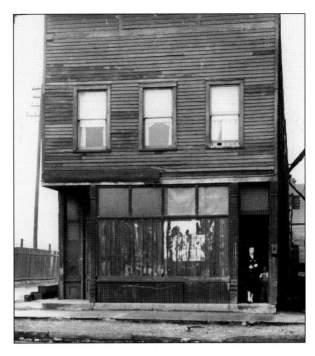

| DEPT. | WEEK | EMPLOYEE | HOURS | BASIC PAY | CLOTH ALLOW | OVERTIME PAY | STANDARDS PREMIUM | GROSS PAY | F.I.C.A. | WITHHOLDING TAX |
|---|---|---|---|---|---|---|---|---|---|---|
| 138 | 04 | 7906 | 39.7 | 95.40 | 50 | | | 95.90 | 2.88 | 12.58 |
| | | | | | | | | | | |

* INCLUDED IN THE ABOVE AMOUNT

| ISSUE DATE | | | E. B. A. | GROUP | BONDS | OTHER INSURANCE | MISCELLANEOUS REGULAR | SMC AUTO INS. OR CODE MISCELLANEOUS | | UNION DUES | NET PAY |
|---|---|---|---|---|---|---|---|---|---|---|---|
| 1 | 29 | 61 | 33 | 1.50 | | | | | | 6.00 | 72.61 |

OTHER DEDUCTIONS
1. STOREROOM
3. SECURITY MUTUAL
4. UNION DUES
7. PAYOFF-VAC., ETC.
8. STATE WH. TAX
9. ALL OTHER

Swift & Company

EARNINGS STATEMENT — RETAIN FOR YOUR RECORD

FORM C-53

Swift and Company employed bricklayer helper Emmanuel Scribano from 1933 until 1965. A 1961 paycheck indicates 39.7 hours for $72.61 net pay. (Courtesy of Connie Scribano Kopulos.)

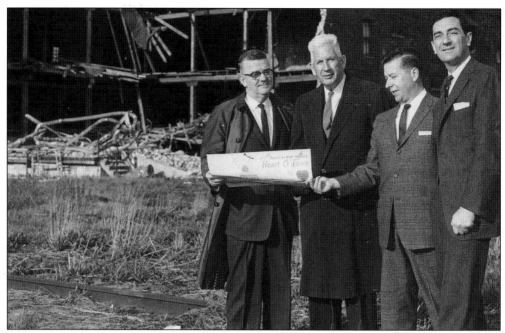

Sen. Paul Douglas (second from left) and the two men on the right are Back of the Yards Neighborhood Council council members standing in the rubble of the stockyards with a promotion paper announcing, "It's hot, Part of the new Chicago Heart O'Town, the Stockyards Industrial Center." This photograph was taken in the late 1960s or early 1970s. (Courtesy of the Back of the Yards Neighborhood Council.)

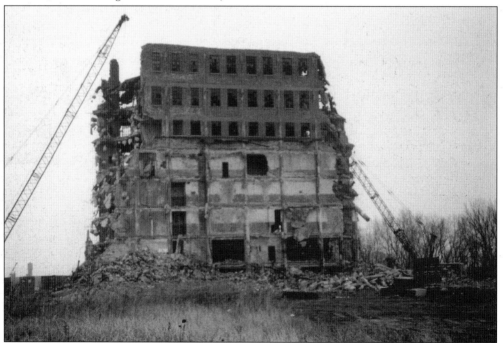

This photograph taken in the early 1970s shows the stockyard being dismantled. (Courtesy of the Back of the Yards Neighborhood Council.)

*Five*

# CHURCHES

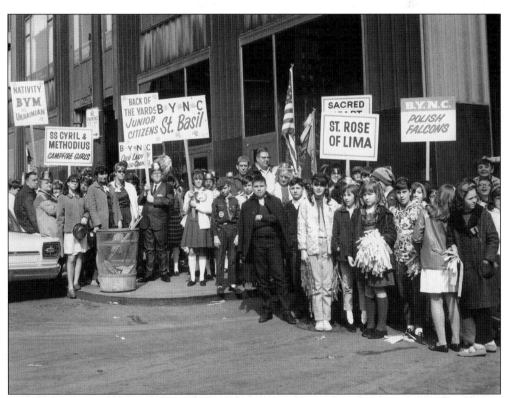

In 1962, the Back of the Yards Neighborhood Council parade groups line up with community-wide representation. Each ethnic group settled in a different area of the neighborhood and attended its own church and school. Over the years, church mergers and closures occurred while others were razed. (Courtesy of the Back of the Yards Neighborhood Council.)

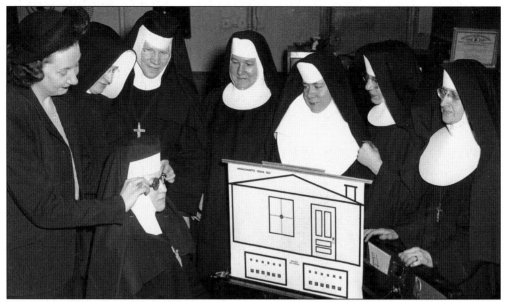

These sisters are getting a vision test. There are various religious orders present. The sister who is seated and one standing above her are Felicians who served at Sacred Heart, St. Joseph, and St. John of God. The third sister from the right is a Mercy sister, from St. Rose of Lima, Sr. Mary Jacinta. The two Benedictine sisters are second and fourth from the right. The sister at the far right is unidentified. The sister on the far left next to the lady may be a sister of St. Francis from Joliet, an order from Sts. Cyril and Methodius. (Courtesy of the Back of the Yards Neighborhood Council.)

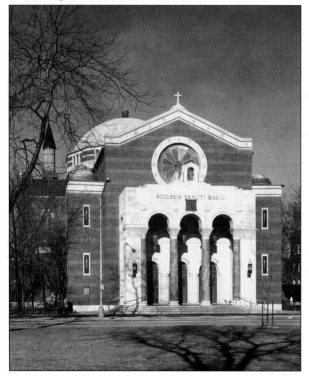

This photograph is of St. Basil Church, an Irish and German church at 1804 West Garfield Boulevard. It was founded in 1904. This church was razed and merged with Visitation Parish. (Photograph by Creative Photography, courtesy of the Back of the Yards Neighborhood Council.)

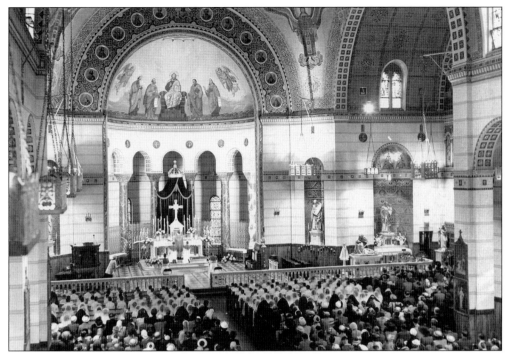

This photograph shows the interior of St. Basil Church. (Photograph by Chicago Lawn Photos, courtesy of the Back of the Yards Neighborhood Council.)

St. Joseph Church, a Polish church located at 4821 South Hermitage Avenue, is seen here at Christmas. The church was founded in 1887. (Courtesy of the Back of the Yards Neighborhood Council.)

Sacred Heart Church, a Polish church founded in 1910 and located at 4619 South Wolcott Street, is pictured here during an outdoor Czestochowa mass. The church has since been razed, and a school is on the site. A former home for Sacred Heart Roman Catholic nuns was located at 4637 South Wolcott Street. The facade featured brickwork in geometric patterns and was topped with a stone cross. (Courtesy of the Back of the Yards Neighborhood Council.)

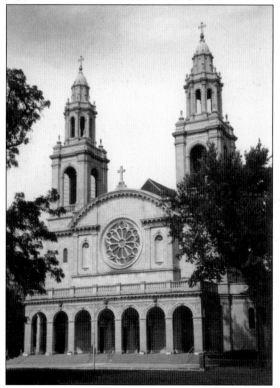

St. John of God Church, a Polish church at Fifty-second and Throop Streets, was founded in 1906 and is shown here closed. (Photography by Chicago Lawn Photos, courtesy of the Back of the Yards Neighborhood Council.)

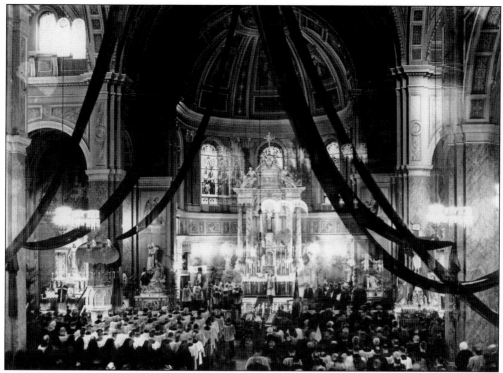

This is an interior shot of the St. John of God Church. (Photograph by Chicago Lawn Photos, courtesy of the Back of the Yards Neighborhood Council.)

On March 5, 1944, Our Lady of Guadalupe was relocated to 4500 South Ashland Avenue and was renamed Immaculate Heart of Mary, which merged in 1980 with Holy Cross, a Lithuanian church. (Courtesy of Fr. Bruce Wellems.)

Communion is being held at Immaculate Heart of Mary, a Hispanic church, in the 1950s. (Courtesy of Fr. Bruce Wellems.)

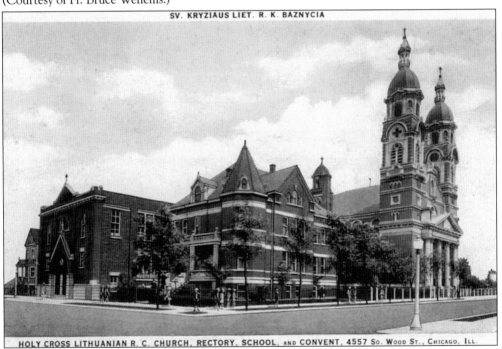

SV. KRYZIAUS LIET. R. K. BAZNYCIA

HOLY CROSS LITHUANIAN R. C. CHURCH, RECTORY, SCHOOL, AND CONVENT, 4557 So. WOOD ST., CHICAGO, ILL.

Holy Cross Parish, a Lithuanian church at 1746 West Forty-sixth Street, was founded in 1904. This 1950s postcard shows the exterior of the church. It is one of three distinct postcard views of the church. (Courtesy of Holy Cross Parish.)

Seen here is the interior of the Holy Cross Church. (Courtesy of Lottie Stegvilas Tervanis.)

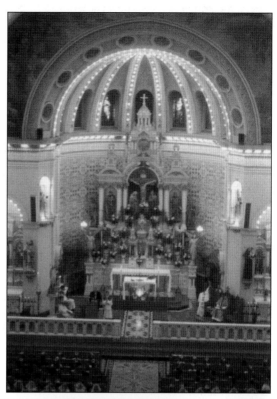

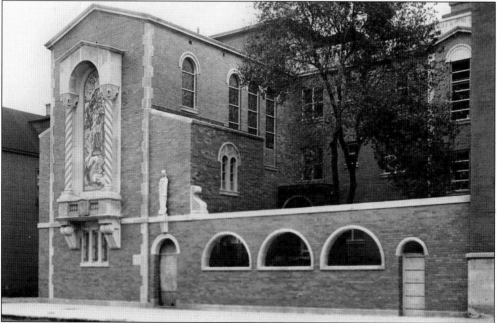

Sisters of St. Casimir served Holy Cross Church in the school and community for 57 years and continues the mission and faith-filled vision of its founder and servant of God, Mother Maria Kaupas. The convent for the Sisters of St. Casimir is located on the 4500 block of South Wood Street. (Courtesy of the Back of the Yards Neighborhood Council.)

Sister M. Cunnegunda is seen here in the middle, with Alvira Kanis, one of the "little sisters," for a play at school at the Holy Cross Grammar School, located at 4500 South Wood Street, in 1947 or 1948. This photograph was taken in front of the convent. (Courtesy of Marlene Traksel Feldhaus.)

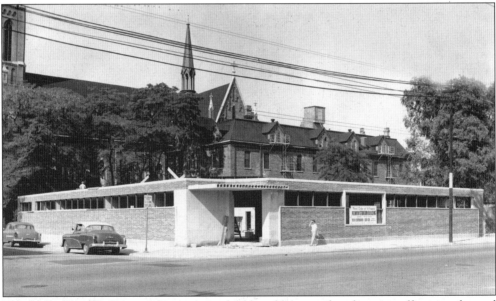

The third order of St. Francis administration building, library, and credit union offices were located at the Franciscan Herald Building at Fifty-first and Laflin Streets, seen here in the late 1950s or early 1960s. Directly behind the Franciscan Herald Building was the convent occupied by the Poor Handmaids of Jesus Christ, who faithfully served the community for many years. Behind the convent is St. Augustine (founded in 1890), a German church located at the 5000 block of South Laflin Street, which was razed. (Courtesy of the Back of the Yards Neighborhood Council.)

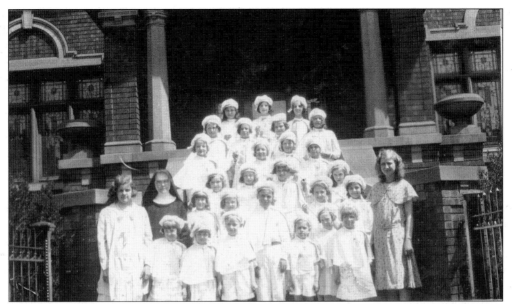

This photograph was taken in front of St. Michael the Archangel Rectory in 1929. St. Michael the Archangel Church, a Slovak church, was located at 4821 South Damen Avenue. In the third row, second from the left is Helen Lach, and to the left of the Sister is Agnes Palenek. Helen Lach later married Carl Bieniek in 1941. The Bienieks had 11 children and were married for 65 years. (Courtesy of Alice Lach Oskvarek.)

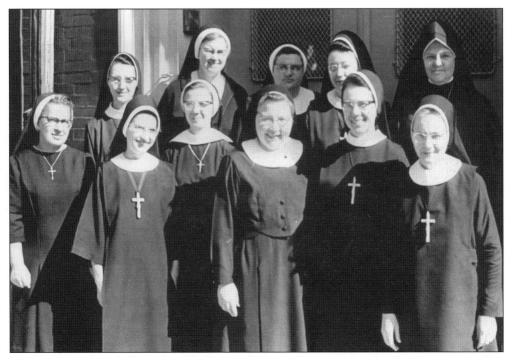

Teachers at St. Joseph School, staffed by the Felician Sisters, congregate for a summer reading program at 4818 South Paulina Street. St. Joseph Parish featured both a grammar and high school. (Courtesy of the Back of the Yards Neighborhood Council.)

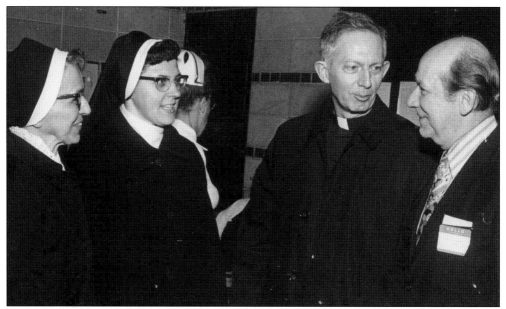

Sister Rita Marie, principal of Holy Cross Grammar School, and Sister Marionette of Holy Cross meet with Rev. Paul Rosemeyer for Career School in the early 1970s. The Back of the Yards Neighborhood Council sponsored Career School and Seminar each year for nearly 1,000 eighth-grade graduates with leaders of business, industry, and other vocations. (Courtesy of the Back of the Yards Neighborhood Council.)

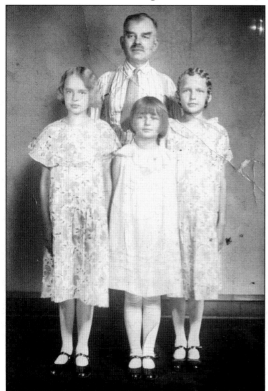

The Vendzelis family, on the 4500 block of South Hermitage Avenue, is pictured here in the late 1930s. Frank was a widower who raised his three daughters, Josephine (left), Stella (center), and Helen. Both Josephine and Helen became sisters with the St. Casimir order. Josephine's name was Sister M. Francetta (after her father, Frank). (Courtesy of Connie Jvarsky and Lottie Stegvilas Tervanis.)

*Six*

# NEIGHBORHOOD
# RESIDENCES

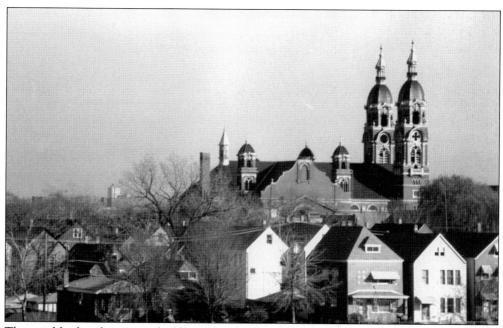

The neighborhood comprised of homes, cottages, and tenement flats is seen with the soaring towers of Holy Cross Church from the Damen Avenue overpass. Today the overpass no longer remains. (Courtesy of the Back of the Yards Neighborhood Council.)

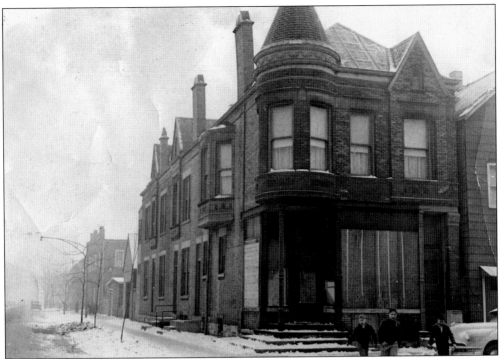

In the 1950s, 4801 South Ada Street was a multiple-tenement building with architectural details in its turrets and a bay window. (Courtesy of the Back of the Yards Neighborhood Council.)

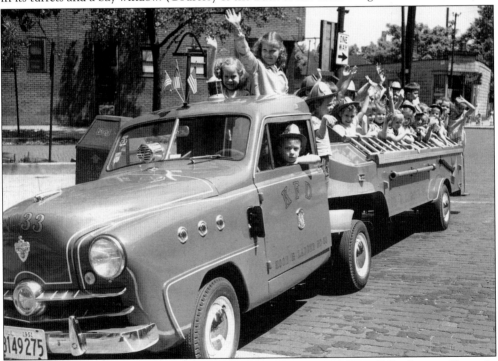

Children go for a ride in hook and ladder No. 33 by the Mary McDowell Settlement House in 1952. (Courtesy of the Back of the Yards Neighborhood Council.)

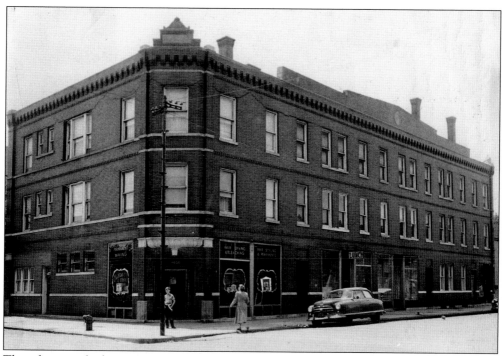

This photograph shows 4600 South Wood Street at the juncture of West Forty-sixth Street in 1963. The building features retail establishments on the first floor and apartments above. (Courtesy of the Back of the Yards Neighborhood Council.)

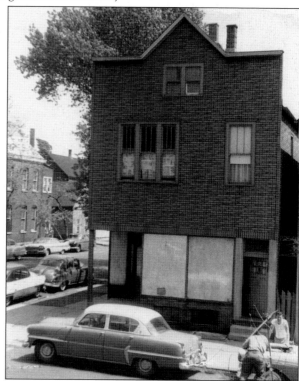

This corner building, with upstairs flats, is located at 4501 South Wood Street and pictured here in 1959. It is across the street from Mankowski's Drug Store. (Courtesy of the Back of the Yards Neighborhood Council.)

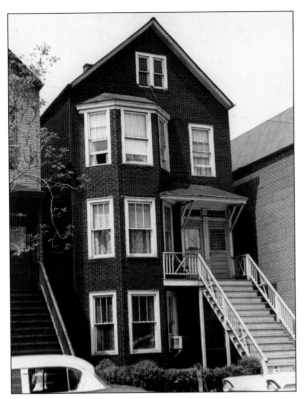

In 1959, 4504 South Wood Street was owned by Ignac Jasaitis. To residents, housing was an important part of life. Ownership provided financial security. Many owners rented out their apartment flats. (Courtesy of the Back of the Yards Neighborhood Council.)

Social networking was evident by walking down the street. Neighbors would carry on conversations through the window or by sitting on the front stairs or cement stoop and talking to passersby. Eugene Pasinski owned 4511 South Wood Street in 1959. (Courtesy of the Back of the Yards Neighborhood Council.)

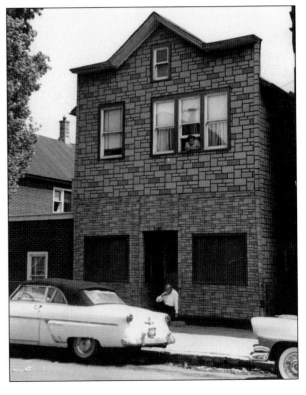

This three-story apartment building at 4521 South Wood Street in 1959 shows the close proximity to next-door neighbors. (Courtesy of the Back of the Yards Neighborhood Council.)

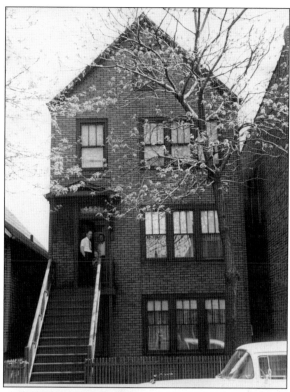

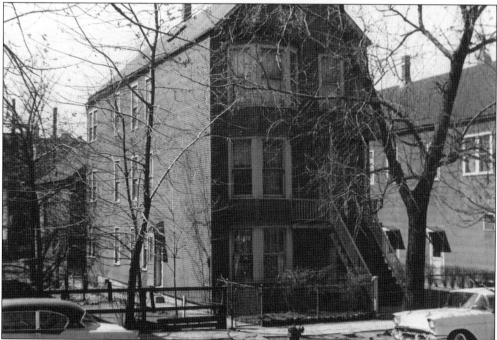

With abundant space alongside it, the Jakimauskas family residence at 4630 South Paulina Street is pictured here in 1959 with the sun shining brightly. (Courtesy of the Back of the Yards Neighborhood Council.)

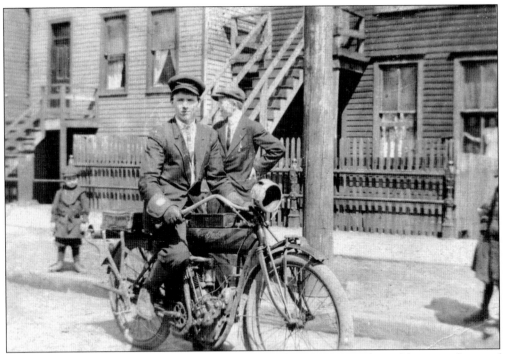

An unidentified man on a motorcycle catches the attention of neighbors in front of residences between 4527 and 4529 South Laflin Street in the early 1900s. (Courtesy of Alice Lach Oskvarek.)

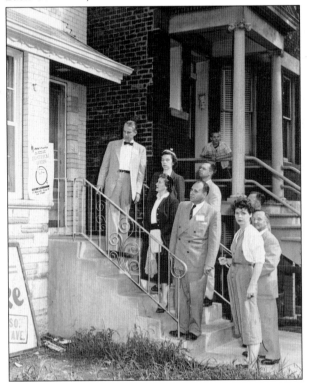

Bringing old homes up to building code was not always feasible or economical. This new brick home at 5029 South Wood Street borders an older home. The Back of the Yards Neighborhood Council sponsored the construction of 800 new homes, sections of which were named Destiny Manor. (Courtesy of the Back of the Yards Neighborhood Council.)

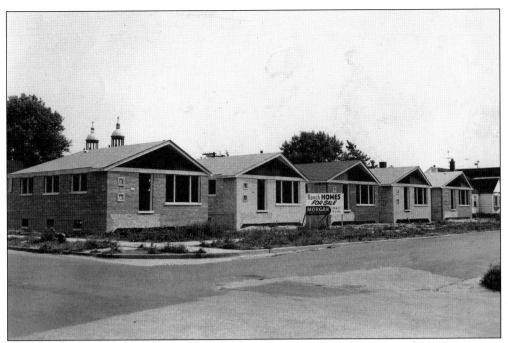

Houses on Morgan Street, between Fiftieth Street and Fiftieth Place, were built by Morgan Construction Company at 2136 West Fifty-first Street. Towers of St. John of God Church appear in the background. (Courtesy of the Back of the Yards Neighborhood Council.)

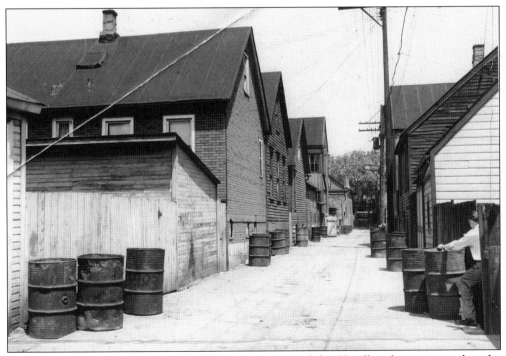

This is a typical alley view in Back of the Yards. Many of the 55-gallon drums pictured in the alley were used as garbage cans. (Courtesy of the Back of the Yards Neighborhood Council.)

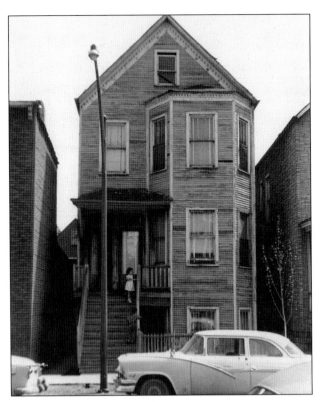

Shown here is 4433 South Wood Street in 1959. Due to the close proximity of buildings and their wood frames, the neighborhood experienced fires each autumn. While growing up, Caryn Olczyk and Therese Taluntis recalled fires on the 4500 block of South Paulina Street and the 4500 block of South Wood Street. (Courtesy of the Back of the Yards Neighborhood Council.)

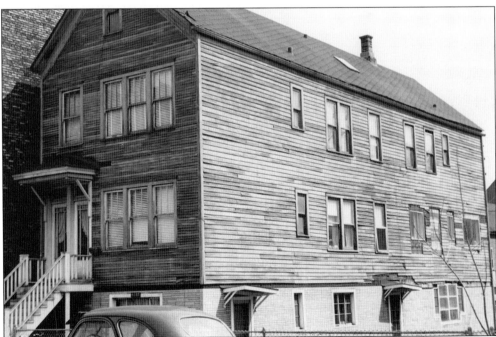

This photograph features 4633 South Hermitage Avenue in 1959. The building next door is the Rytina Baking Company, which later became Baltic Bakery. This apartment building features a unique and highly coveted side yard. (Courtesy of the Back of the Yards Neighborhood Council.)

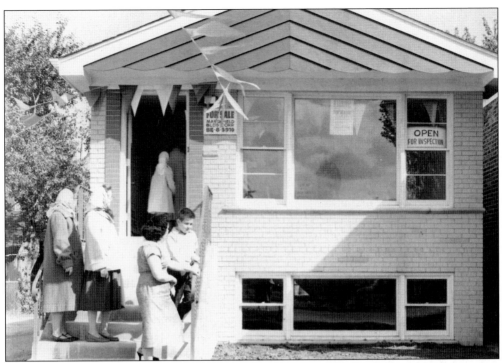

This photograph shows the 4511 South Wolcott Street model home open for inspection. (Courtesy of the Back of the Yards Neighborhood Council.)

Harriet Norbut owned 4500 South Paulina Street in 1962. In the mid-1960s a hamburger stand with the best burgers and fries opened on the Forty-fifth Street side of the building across from Davis Square Park. (Courtesy of the Back of the Yards Neighborhood Council.)

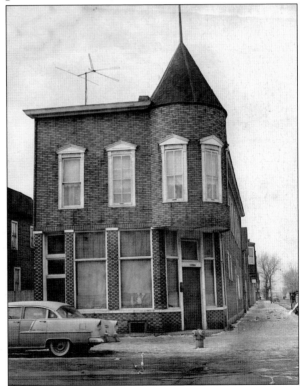

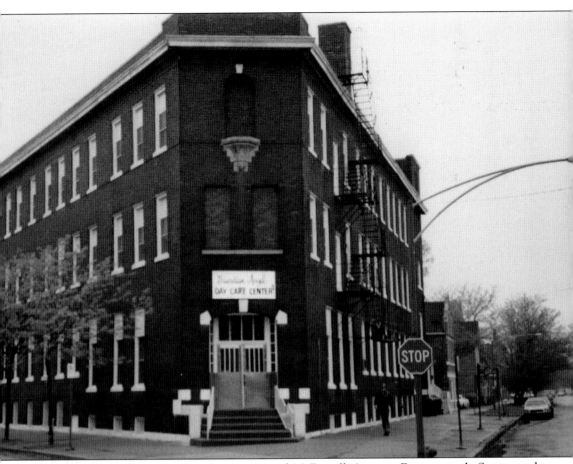

A quadrangle of buildings at the juncture of McDowell Avenue, Forty-seventh Street, and Ashland Avenue hosted the University of Chicago Mary McDowell Settlement. A few doors away was the Guardian Angel Day Nursery and Home for Working Girls. Fr. Louis Grudzinski started the establishment. It provided services to working mothers to care for their children, accommodations for new immigrant young girls, and a medical clinic. Kay M. Kempke, Tom Doyle, and Rose Gaura Doyle provided substantial information on the McDowell Settlement House. Tom lived and worked as an educator at the McDowell Settlement House and later became principal. Rose worked with the club groups. Kay wrote an extensive paper on the McDowell Settlement House. (Courtesy of the Back of the Yards Neighborhood Council.)

*Seven*

# CHICAGO'S FREE FAIR

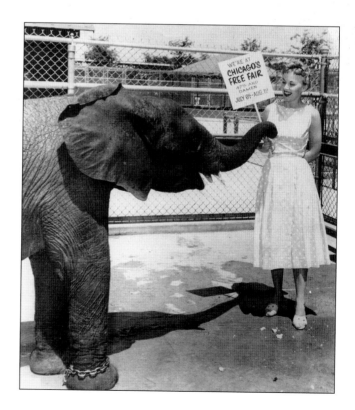

Welcome to Chicago's Back
of the Yards Free Fair located
at Forty-seventh Street and
Damen Avenue. (Courtesy
of the Back of the Yards
Neighborhood Council.)

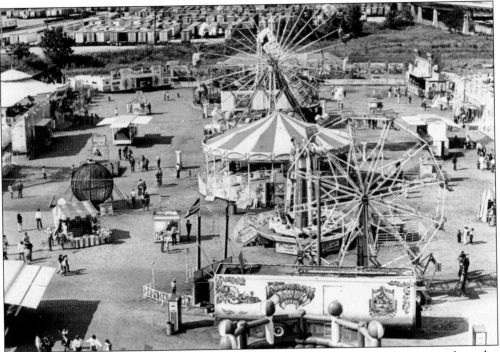

This view of the free fair looks north with the Damen Avenue overpass adjacent on the right. (Photograph by Bob Mason, courtesy of the Back of the Yards Neighborhood Council.)

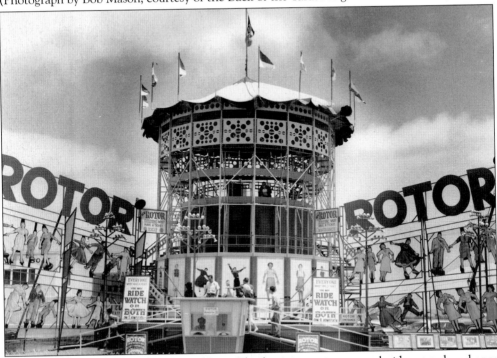

The Rotor ride at the free fair is pictured here. This historic amusement park ride rotated, and once it reached full speed, the floor retracted, leaving the riders stuck to the wall. Most Rotor rides were constructed with an observation deck. (Courtesy of the Back of the Yards Neighborhood Council.)

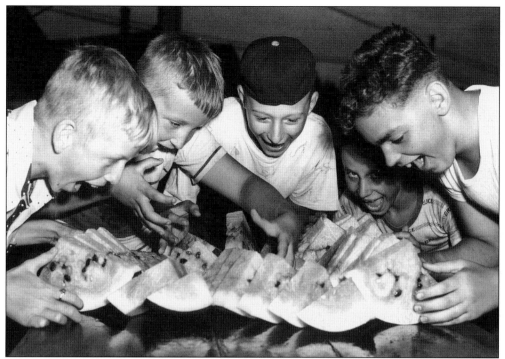

The watermelon eating contest at the free fair is seen here in the 1950s or 1960s. Everyday there were contests at the fair. (Courtesy of the Back of the Yards Neighborhood Council.)

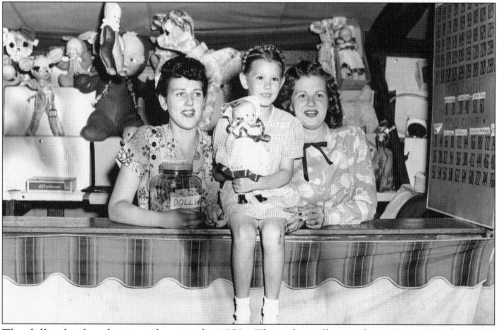

The doll ticket booth is seen here in the 1950s. The ticket sellers and winner are unidentified. The free fair had many chance booths and skill games of chance, including the goldfish booth. Many neighbors and friends worked the ticket chance prize booths over the years. (Courtesy of the Back of the Yards Neighborhood Council.)

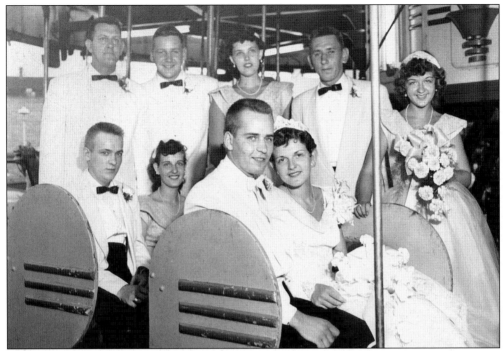

This 1950s or 1960s unidentified bride and groom and their wedding party take a ride on the merry-go-round. (Courtesy of the Back of the Yards Neighborhood Council.)

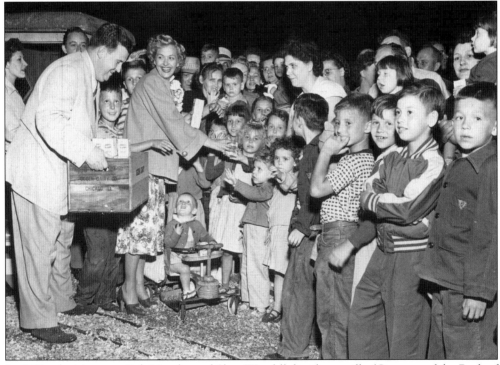

In 1950, television stars Bob Murphy and Shay Westfall distribute milk. (Courtesy of the Back of the Yards Neighborhood Council.)

Mary Hartline of the Howdy Doody television show smiles for the camera and signs autographs at the 1951 fair. (Courtesy of the Back of the Yards Neighborhood Council.)

Unidentified pigtail contest entries are seen here in 1952. (Courtesy of the Back of the Yards Neighborhood Council.)

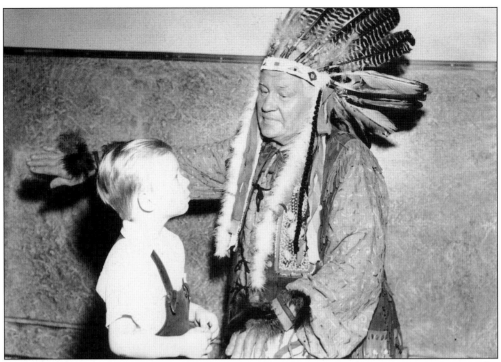

Chuckie Sheane, age 3, of 5118 South Hermitage Avenue visits with Native Americans at the 1952 fair. (Courtesy of the Back of the Yards Neighborhood Council.)

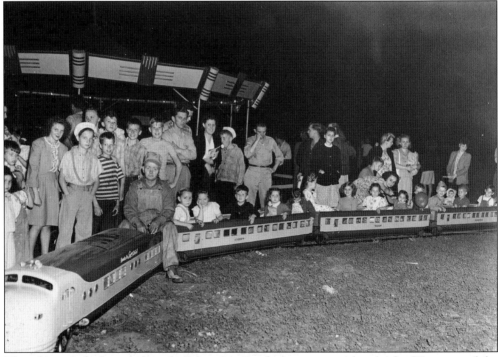

This photograph shows kids and adults enjoying the miniature railroad ride. (Courtesy of the Back of the Yards Neighborhood Council.)

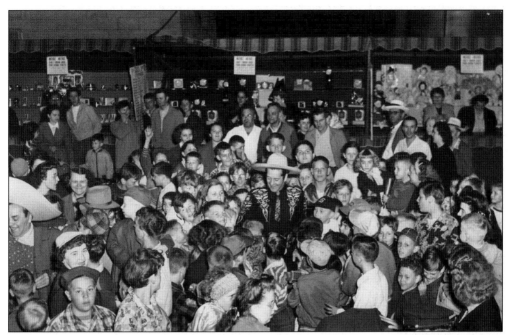

With ticket booths in the background, youngsters crowd around Duncan Renaldo, the "Cisco Kid," in this 1952 photograph. Evelyn Ostrowski, a social worker for the McDowell Settlement is identified in the crowd at the far left side behind the boy with the cap who is looking at the camera. (Courtesy of the Back of the Yards Neighborhood Council.)

Kathleen Doyle of 438 West Root Street enjoys fluffy, warm cotton candy that was spun onto a paper cone. The free fair was the place to discover different foods like corn dogs and delicious blocks of vanilla ice cream on sticks that were dipped in melted chocolate and rolled in chopped peanuts. (Courtesy of the Back of the Yards Neighborhood Council.)

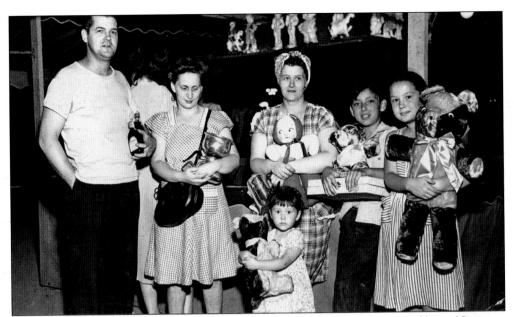

Unidentified winners and their prizes from ticket booths and games are pictured here. (Courtesy of the Back of the Yards Neighborhood Council.)

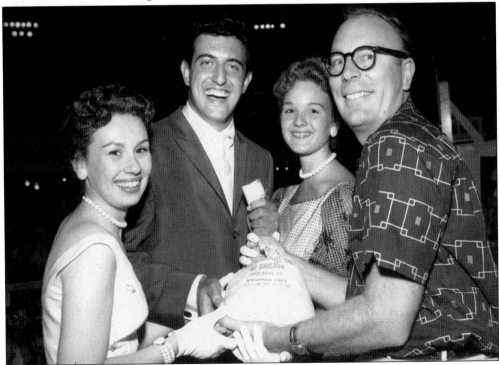

Radio station WBBM Nite at the fair features, from left to right, Carol March, Bob Vegas, Susan Abbott, and Mal Bellairs. They are taking a look at the sample of the money that Marion Krawiak won in the Weigh in the Money contest. Bellairs was the host of the all-live musical *Music Wagon* and host to his own record show, *Bellairs Show*. (Courtesy of the Back of the Yards Neighborhood Council.)

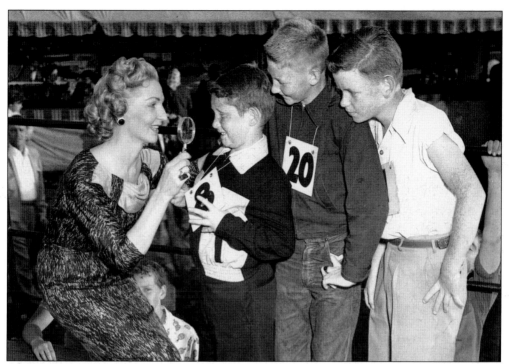

Carole Grabowski checks out the 1957 freckle contest entrants. (Courtesy of the Back of the Yards Neighborhood Council.)

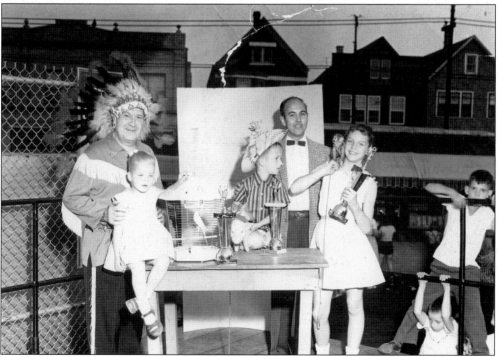

Winners of the 1958 cutest pet contest are seen here. (Courtesy of the Back of the Yards Neighborhood Council.)

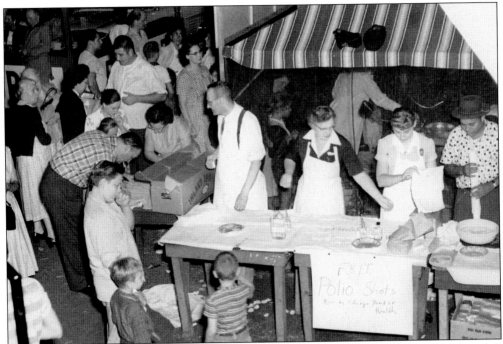

The board of health administered free polio shots in 1958. Pictured behind the table, from left to right, are Dr. Stenn, Miss Killeen, Miss Kiskovic, and Mr. Burgess. (Courtesy of the Back of the Yards Neighborhood Council.)

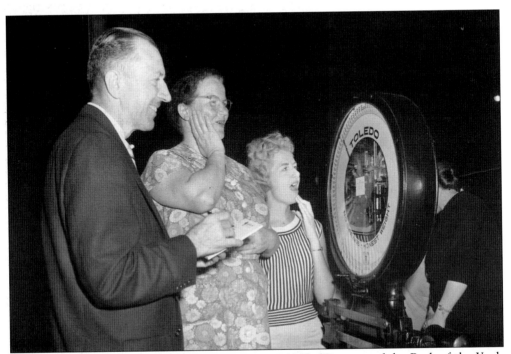

Two women weigh in for a weight losing contest in 1968. (Courtesy of the Back of the Yards Neighborhood Council.)

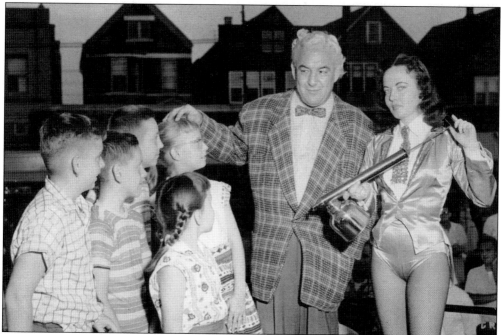

Wrestler George "Gorgeous George" Raymond Wagner works the crowd while his assistant sprays the crowd with a perfumed disinfectant called "GG" in 1958. (Courtesy of the Back of the Yards Neighborhood Council.)

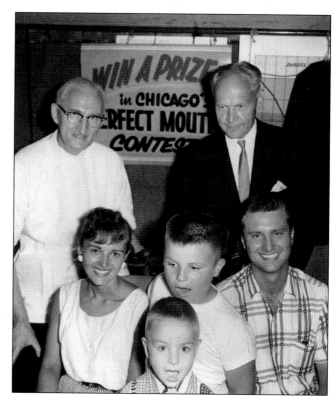

In 1958, winners and dentists smile for the camera in the perfect mouth contest. (Courtesy of the Back of the Yards Neighborhood Council.)

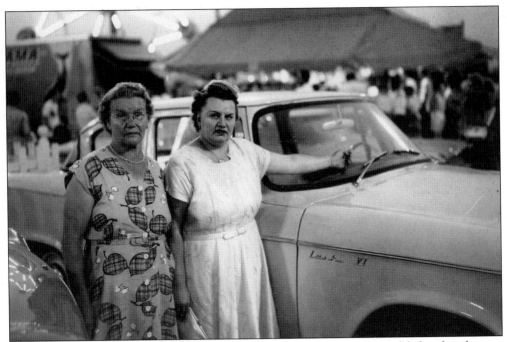

Joanne Sperlac, of 4725 South Justine Street, looks over her new Lark by Studebaker that she won at the free fair in 1960. The only problem was that neither Joanne nor her mother (left) could drive, but both were willing to learn. (Courtesy of the Back of the Yards Neighborhood Council.)

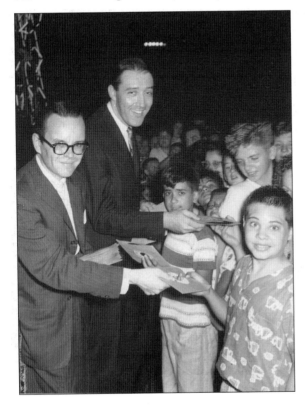

Ted Lee (left) and Jack Spector gave out 5,000 records to their fans on WJJD night. (Courtesy of the Back of the Yards Neighborhood Council.)

A clown plays onstage with the double Ferris wheel aglow in the background at sunset in 1960. (Courtesy of the Back of the Yards Neighborhood Council.)

Unidentified winners of ticket booths, games, and contests are having a great time. (Courtesy of the Back of the Yards Neighborhood Council.)

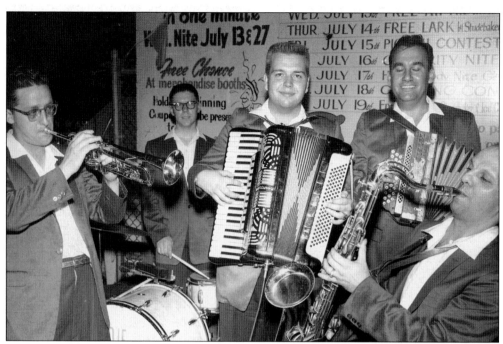

Entertainment is being provided by an unidentified musical group onstage. Every night there was always a variety of musical entertainment. (Courtesy of the Back of the Yards Neighborhood Council.)

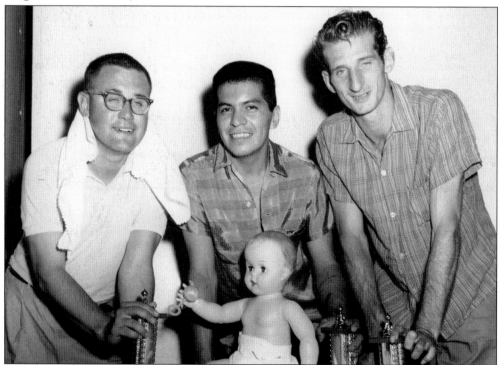

Baby diapering contestants are seen here in 1960. (Photograph by PICS Chicago, courtesy of the Back of the Yards Neighborhood Council.)

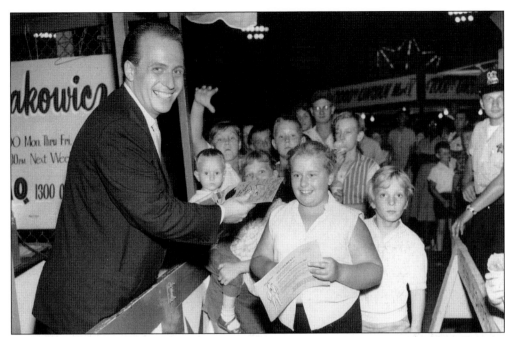

Stan Dale, a popular WAIT disc jockey, was confronted by thousands of his fans when he announced that he was going to give away free records until there were no more. A seemingly endless line was formed, and Dale passed out records until what looked like an inexhaustible supply ran out. (Courtesy of the Back of the Yards Neighborhood Council.)

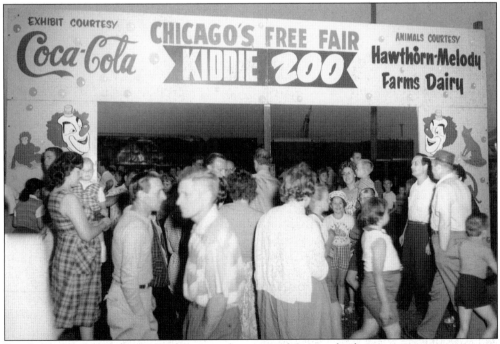

People pass by the free fair kiddie zoo area where animals are on display in a petting zoo, courtesy of Coca-Cola and Hawthorn-Melody Farms Dairy in 1960. (Courtesy of the Back of the Yards Neighborhood Council.)

# ACROSS AMERICA, PEOPLE ARE DISCOVERING
# SOMETHING WONDERFUL. *THEIR HERITAGE.*

Arcadia Publishing is the leading local history publisher in the United States. With more than 3,000 titles in print and hundreds of new titles released every year, Arcadia has extensive specialized experience chronicling the history of communities and celebrating America's hidden stories, bringing to life the people, places, and events from the past. To discover the history of other communities across the nation, please visit:

# www.arcadiapublishing.com

Customized search tools allow you to find regional history books about the town where you grew up, the cities where your friends and family live, the town where your parents met, or even that retirement spot you've been dreaming about.